IMAGES
of America

WEST COLUMBUS

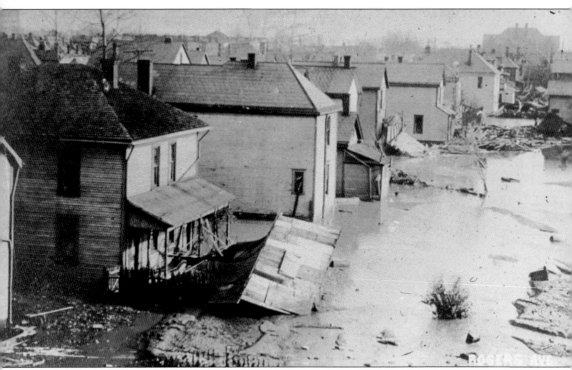

When settler Lucas Sullivant founded the community of Franklinton in 1797, he was forced to relocate the village a year later farther down the banks of the Scioto River. The deadly waters of the Scioto washed away hundreds of businesses and houses during the first 100 years of development, but it could never wash away the determination of its residents to build a home. (Courtesy of the Columbus Metropolitan Library.)

ON THE COVER: In the 1940s, statewide blue laws guaranteed the community had Sunday off. Favorite pastimes included working on go-karts and racing them around the parking lot at Central Point Shopping Center. The racing weekly event attracted crowds to watch the kids speed around. Pictured are, from left to right, hobby racers Norman Davis, Dick Dorr, and Wilson Black. (Courtesy of David Miller.)

IMAGES
of America

WEST COLUMBUS

Sean V. Lehosit

ARCADIA
PUBLISHING

Copyright © 2015 by Sean V. Lehosit
ISBN 978-1-4671-1463-9

Published by Arcadia Publishing
Charleston, South Carolina

Printed in the United States of America

Library of Congress Control Number: 2015935033

For all general information, please contact Arcadia Publishing:
Telephone 843-853-2070
Fax 843-853-0044
E-mail sales@arcadiapublishing.com
For customer service and orders:
Toll-Free 1-888-313-2665

Visit us on the Internet at www.arcadiapublishing.com

*To my wife, Kara, and our son, Kade, who
have enriched my own history*

Contents

ACKNOWLEDGMENTS

I recall spending many summer nights sitting with friends outside the "Hill Top Dairy Twist," as the infamously misspelled sign for the Hilltop Dairy Twist read, enjoying one of their 40 flavors of ice cream and staring at the statue of a Civil War soldier who peaked over the stone wall at the Camp Chase Confederate Cemetery.

There are only so much insights historical markers and cornerstones can tell about these landmarks, the rest must come from people, and I have plenty to thank. The two historians who were the most helpful in framing the history of the Hilltop and Franklinton are Bea Murphy and Monty Chase, who endlessly work toward preserving the history of our neighborhoods.

I would also like to thank Aaron O'Donovan and Brian Stettner of the Columbus Metropolitan Library for their knowledge and assistance in utilizing library resources. I am also appreciative for the cooperation of the West High School Alumni Association, Westgate Neighbor Association, the Lutheran Social Services of Central Ohio and Southwest Public Libraries.

Additional thanks go to Hope Moore, who passed along historical news clippings and period postcards; Dan Gatwood, for his tour and information on the history of Parkview United Methodist Church; Nola Freeman, for materials on the Rome settlement; and residents Michelle Barr, Bonnie Bell, and David Miller, for permitting use of their stunning photographs of area businesses and the flood of 1959.

I would lastly like to thank my title manager at Arcadia Publishing, Liz Gurley, for her guidance and ensuring I was always on track by answering questions, providing support, and reminding me of approaching deadlines.

INTRODUCTION

Following the Revolutionary War, approximately 4.2 million acres of land was labeled the Virginia Military District and used to pay Virginian officers for their services. So, in the late 1790s, many officers hired surveyors to scope the land bordered by the Ohio River to the south, Little Miami River to the west, and the Scioto River to the east and north.

In 1795, the Commonwealth of Virginia hired Lucas Sullivant to lead a survey team of assistants, scouts, and hunters into the northern part of the Virginia Military District, which would bring them to the banks of the Scioto River.

It was common for surveyors to be paid in land, so Sullivant kept an eye out for potential community spots he liked; the one that seemed the most promising was land just west of the Scioto River. With the 6,000 acres he received as payment, he created Franklinton as the first settlement in Central Ohio. It was named after Benjamin Franklin, who he admired greatly and had recently passed.

Over the next few decades, other settlements began to emerge nearby. While Lucas chose to remain in Franklinton, his sons Michael and William Starling bought land from him west of his settlement and above the river level. This new area for farming was called Sullivant's Hill, and Franklinton became lovingly referred to as "the Bottoms."

Present-day West Columbus was touched by two military conflicts during its formative years. Franklinton was used as a staging point for William Henry Harrison and his men during the War of 1812. Then, during the Civil War, the Union leased land on Sullivant's Hill to establish a volunteer regiment training camp, Camp Chase. The site was converted into a Confederate prison and cemetery, which remains one of the most noteworthy historical attractions in the region.

The abandonment of Camp Chase rose opportunity for Quaker settlers to invest in the farmlands. It could be said these religious folk are one of the reasons faith remained an important pillar in the lives of many West Columbus residents. Churches were an important part of everyday life and the venues for a lot of social events in the early 1900s.

In 1812, the City of Columbus was founded on the opposite Franklinton at the Scioto River. Most of the settlements in the county fell within the borders of Franklin Township, which covered the most territory out of any other township. Columbus was aggressive with its annexation, though, and began to absorb one community after another in 1859.

In 1863, Columbus owned 1,100 acres of land. It annexed an additional 2,740 acres of land from Franklin Township over the next 10 years. The city would continue this practice over the next 100 years and spread its territory in all directions—north, south, east and west.

The western region, known as West Columbus, became a collective of neighborhoods that weaved together uniformly due to the heavy land use of farming over the better portion of a century.

West Columbus begins with the Franklinton area and continued to annex acreage and grow so it is bordered by West Jefferson to the west, Hilliard to the north, and Grove City to the south. Other unincorporated villages or townships are small enclaves that are absorbed more by West Columbus every year.

The largest area within West Columbus is the Hilltop, which is broken down into subdivisions. Many of the early subdivisions were named after early settlers or influential politicians like the area of Briggsdale, Franklinton, or Camp Chase, which all still exists. Other neighborhoods were created by realty investors and products of the streetcar system era, like Westgate.

Flooding could have smothered out the region, and it almost did the first year Sullivant settled in Franklinton. However, the early settlers were hardworking farm laborers and persevered. The railroad industry transformed them from a rural region into an industrial one. The stable work and the introduction of streetcars swelled the population, so it could sustain a transition to commercial retail in the 1920s.

The main two commercial corridors were Broad Street and Sullivant Avenue. Both roads became lined with family businesses and prosperity through the 1940s, when following World War II, the Fisher Body Plant was built at the western outskirts of the Hilltop, at West Broad Street and Georgesville Road. Once again, West Columbus was happy to transition.

More and more automobile-oriented businesses opened up on the Hilltop, and the car manufacturer employed many residents. The company performed well in profits during wartime, and demand was higher than ever. Even in Franklinton, the family-owned A.D. Farrow arrived in 1941 and remained there to become the oldest Harley-Davidson dealership in the United States today.

Commerce was doing so well, a group of businessmen got together and formed the Hilltop Business Association. The organization created a support structure to aid, promote, and further commercial efforts in the neighborhoods. It also started the annual Bean Dinner, which weaved together the communities' past and present histories every summer at Westgate Park. Politicians could come out to introduce themselves to residents, businesses could hawk their items, organizations could recruit new members, and it was also chance for residents and churches to come out and socialize. The event began to see as many as 10,000 visitors each year, with outside people even coming in to watch the parade and enjoy cornbread and beans.

Life was great for residents of West Columbus by 1950. There was a healthy and expanding environment for family enterprises and plenty of stable and good-paying work, and the town's favorite baseball team, the Columbus Red Birds, had won the Junior World Series a total of six times since construction of the new stadium in Franklinton.

The future of West Columbus became economically grim a few decades from this point, and it could very well be that the community became a victim of its own growth and success. The region later struggled as factories closed, baseball moved away, and with less money to spend, the retail corridors dried up. However, just as the people did not let the flooding waters of Scioto River drown them, people today are finding ways to rebuild.

One

THE EARLY SETTLERS
SETTING THE STAGE
FOR WEST COLUMBUS

When surveyor Lucas Sullivant founded the Franklinton area, named after Benjamin Franklin, in 1977, he platted 220 lots. After the original village was nearly sunken by the Scioto River, Sullivant moved his settlement and offered free land to anyone near the eastern edge of the plat, hence the name Gift Street.

Some of the first arrivals to the new land were Samuel McElvain and Robert Armstrong in 1797, Joseph Foos and Abraham Deardurff in 1798, James Scott in 1799, Arthur O'Harra in 1800, John Huffman and Adam Hosack in 1801, and Rev. James Hoge in 1803.

These men's names now decorate buildings, churches, and schools. They helped build a small farming community into a hub of commerce and industry, and their efforts brought together the collective neighborhoods known today as West Columbus.

Military general Joseph Foos owned one of the first taverns in Franklinton and became Franklin County's first associate judge in 1802. He was also a fervent admirer of explorer Christopher Columbus.

Not all the early settlers had political aspirations like Foos and Sullivant, who also served as the first clerk for Franklin County. Some of these pioneers came looking for work. Deardurff was a German immigrant who meant to just pass through Franklinton to sell goods to the Native Americans. O'Harra was of Virginian bricklayer who arrived looking for stable work. Hosack found work as the community's first postmaster in 1805. Other pioneers grew skilled in the initial trade of agriculture.

Frederick Cole was another surveyor who was hired by former military officers to survey land in the Virginia Military District. He platted a community in far West Columbus called Rome in 1836, while Sullivant's platted settlement was well off the ground.

Both communities were part of Franklin Township at one time, but as Columbus aggressively annexed land over the next 100 years, they would both become part of West Columbus, with one at the near west, the other on the far west. While the neighborhoods of Franklinton and the Hilltop transitioned to be more commerce based, the far west retained much more of its farming origins.

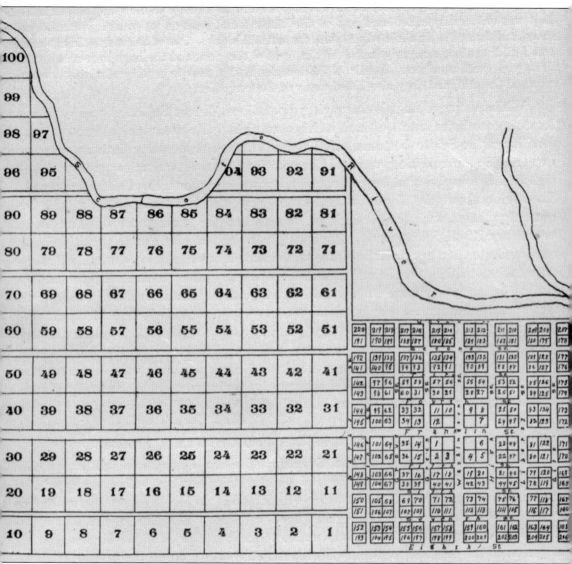

Lucas Sullivant originally platted his community with 220 lots opposite the position where the Scioto River forks. He planned to sell the lots on a specific day, but just prior to the appointed day, the great flood of 1798 swallowed the land. This event is what pushed Sullivant to draw another plat adjacent to the original location. Farmland was sold for about $2 per acre. When Sullivant was first tapped to survey the Virginia Military District, he assembled a crew of about 20 other men. During their journey, they ran into several conflicts with Native Americans in the Ohio Territory. Wyandot and Shawnee Indians inhabited the land around the Scioto River. Early settlers had to cope in the beginning with potential ambushes at any time. Over the years, Sullivant and other settlers were able to reach trade agreements with the Natives Americans. (Courtesy of the Columbus Metropolitan Library.)

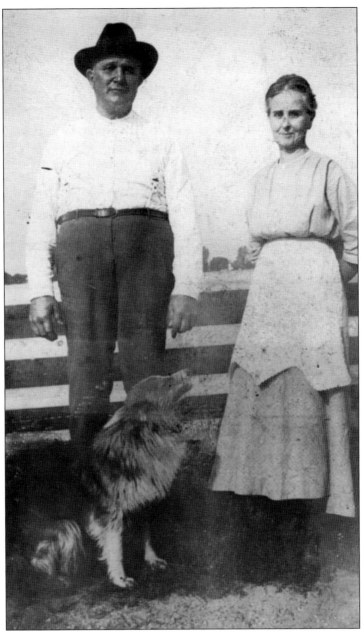

In 1834, a farmer named William T. Clime settled on 116 acres of land just south of present-day Clime Road. The acreage was formerly Virginia Military District. His grandson Lester, pictured with wife Lydia, inherited the property and used it to breed Poland China hogs. He helped expand the property to more than 400 acres, where it is now called the Riverbend neighborhood. This neighborhood is bordered by Clime Road to the north, Alkire Road to the south, and Georgesville Road to the west. The Baltimore & Ohio Railroad also ran to the east of the neighborhood. In 1879, William was named an officer to the Patrons of Husbandry, or Grangers, a society popularized amongst farmers. His chapter was the Camp Chase Grange No. 528, which was first organized on February 11, 1874; its members would meet in the schoolhouse of subdistrict No. 3. (Courtesy of Bonnie Bell.)

One of the first homes in Franklinton belonged to John Brickell when he arrived in 1798. He was one of the first settlers to create a home in West Columbus after Lucas Sullivant pushed the community a few miles east of the Scioto River. Brickell has a unique story, having spent most of his life as a captive of Delaware Indians. He was born near Pittsburgh, Pennsylvania, and was captured by Native Americans when he was 10 years old. The Delaware Indians adopted him, and he spent his formative years living amongst their community along the Maumee River. He was released in result of the Treaty of Greeneville in 1795, just a few years before arriving in Franklinton. Although he was now free, Brickell continued to practice the customs and traditions he learned from the Native Americans. (Courtesy of the Columbus Metropolitan Library.)

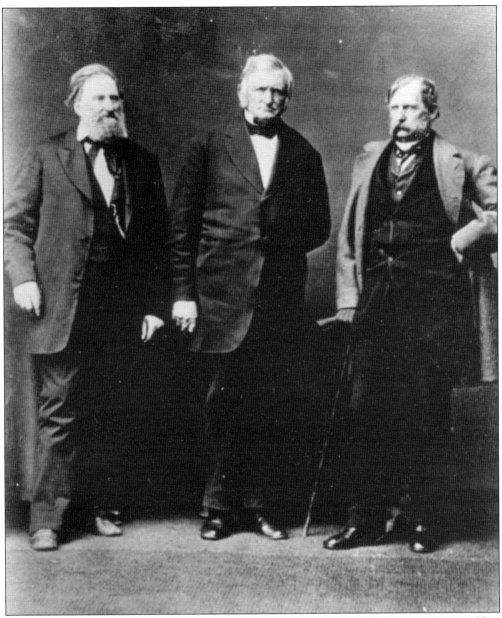

The first landowners on the Hilltop were William Starling and Michael Sullivant, the two oldest sons of Franklinton founder Lucas Sullivant. They were given and purchased around 1,600 acres of land from their father between 1804 and 1888. Michael received the most land in what was referred to as Sullivant's Hill, which he used for farming and raising cattle. He was also the first Franklin County resident to use power threshing machines and reapers. Michael and his sister Sarah built a home in 1835 at 2690 West Broad Street, between present-day South Harris Avenue and South Ogden Avenue, which was demolished in 1950. An earlier home was built where the Columbus State Hospital was later erected. Michael eventually moved to Illinois, where he continued to farm on his 80,000 acres of land. Pictured above are Sullivant's three sons, from left to right, Joseph, Michael, and William Starling Sullivant. (Courtesy of the Columbus Metropolitan Library.)

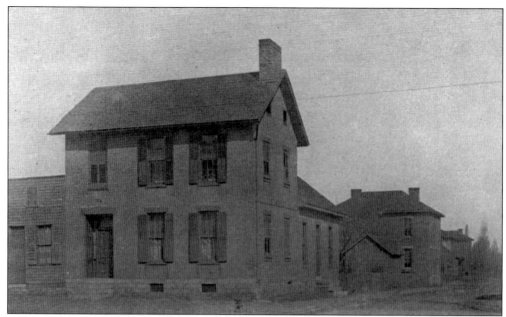

The population in Franklinton increased during the War of 1812 when Gen. William Henry Harrison assembled more than 700 men of the 3rd Ohio Volunteer Regiment in Franklinton and used the two-story, brick residence 570 West Broad Street as a base for operations. Franklinton was used as a staging point throughout the war. The Harrison House was later used in the Civil War by Confederate spy A.J. Marlowe to report his findings from Camp Chase. In the 1980s, the Harrison House became the headquarters to the Franklin County Genealogy Society, as seen below. (Above, courtesy of the Columbus Metropolitan Library; below, courtesy of the Southwest Public Libraries.)

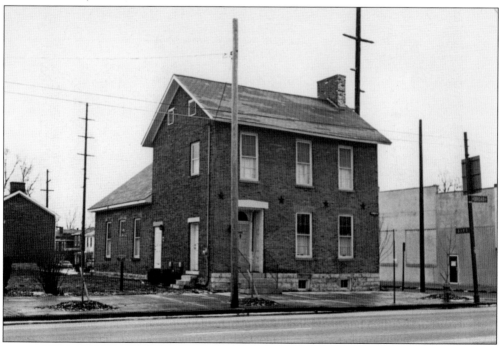

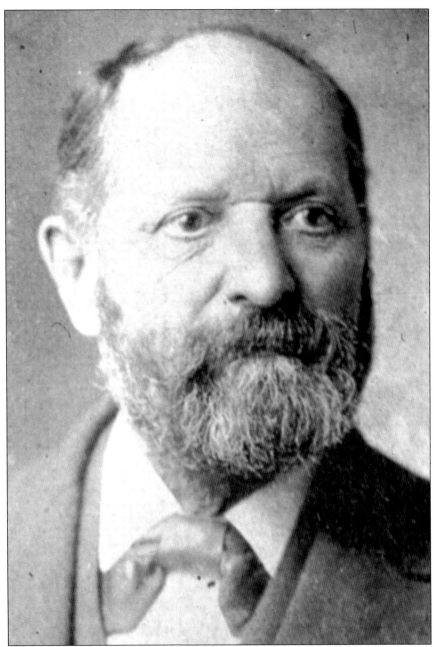

Joseph Briggs was born in November 1833 on his father's farm on Sullivant's Hill. The farm stretched along present-day Briggs Road, bounded by Clime Road, Demorest Road, Eakin Road, and Brown Road. His father, Henry, was the caretaker of Camp Chase Confederate Cemetery. He later became Franklin County commissioner from 1880 to 1887. Briggs High School would later be named in honor of the family. Joseph lived to the age of 80 years old, when his life was stopped short from injuries received in a car crash. He was riding with friend Theodore Connors when an electric streetcar crashed into his buggy at the corner of Glenwood Avenue and West Mound Street. Joseph was rushed to Mount Carmel Hospital, but he lost an eye suffered other severe wounds. (Courtesy of the Columbus Metropolitan Library.)

Louisiana Ransburgh Briggs was the wife of Joseph Briggs. Over the years, she has become a figure of intrigue to present-day residents who refer to her as the "veiled lady of Camp Chase." Every year, she would visit the cemetery in the same gray veil and place flowers on the graves of Confederate soldiers. This tradition continues to be reenacted until this day by history buffs and historical societies. She also went by the nickname "Grandma" to many of her friends and family in Briggsdale. Louisiana lived to be 100 years old, and to her dying day, she was a fan of parties. She carried a reputation for throwing surprise parties whenever she had the chance. Although she loved people, she disliked publicity, which she got plenty of due to being the first woman to decorate the graves at Camp Chase. (Courtesy of the Columbus Metropolitan Library.)

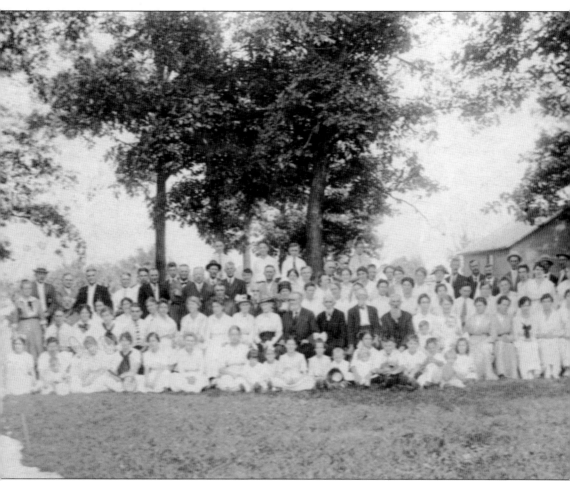

Pictured above is the Briggs family reunion around 1920. The farmstead used to sit on present-day Briggs Road in the southern part of the Hilltop area. The eldest of the family, Joseph Briggs was very involved with the district schools and was made postmaster of Briggsdale in 1887. The Columbus City Schools District would later build its second public high school in West Columbus and name it in honor of the Briggs family. Located in the area the old farmstead used to sit, Briggs High School was built after 1950. Enrollment for students living on the Hilltop was split between West High School and Briggs High School, which created a healthy sports rivalry over the years. Notable alumni from the high school include former Cincinnati Reds player Tom Shearn and Cincinnati Bengals defensive back Ty Howard. (Courtesy of Bonnie Bell.)

The home of Elise Vanderberg was built during the Civil War era and sat on 163 acres of farmland. It was located at 787 South Harris Avenue in the Hilltop neighborhood. The land was originally sold by Michael Sullivant to John Briggs, the grandfather of Elise, following the Civil War. At the time it was purchased, the land was covered in sweet apple trees, but during the course of 30 years, much of the land became developed and not much survives today in the terms of wild fruit. During the Civil War, members of the family would often gather up the sweet apples and take them to sell to officers at Camp Chase. The residence was also hand built, with each brick being hauled from the Thomas's Brickyard. (Courtesy of Bonnie Bell.)

Timothy C. Bigelow came from a large family of 17 in Pennsylvania. They moved to Madison County in Ohio when he was still quite young. After marrying his sweetheart, Hannah Marshal, they settled in Camp Chase, where they opened the Old Four Mile Inn. Timothy also became a successful horse breeder with business partner Marcus Brown of Circleville. The men bought, raised, and sold prizewinning Percherons under their business Brown, Bigelow & Co. There were only three breeders of Percherons in Ohio in the 1860s, and Timothy even received worldwide recognition for his best horse, Napoleon, at the 1866 World's Fair in Rouen, France. His two other top horses were named Black Robert and Duke of France. They continued to find success until Timothy's death at Camp Chase on June 10, 1876, when he was attacked and killed by one of his horses. (Courtesy of the Columbus Metropolitan Library.)

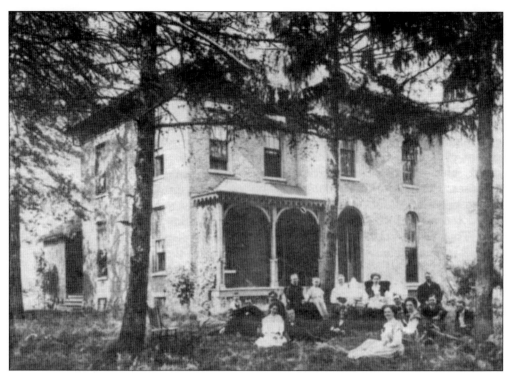

The first home in the Rome settlement was the farmstead of James Kinnaird. He purchased 261 acres of land around 1856 for the price of $11,000. Kinnaird was pivotal in the later placement of Hilliard-Rome Road. Following his death, two developers, Pierce and Thomas Gregg bought the land around 1907 and then sold it to Little Farms Realty Co. in 1911, along with property between the Pennsylvania Railroad and the National Road. The home was used this time as a boardinghouse, as seen above. The farmstead still stands today and celebrated its sesquicentennial in 2011, as pictured below. (Both, courtesy of Columbus Messenger Newspapers.)

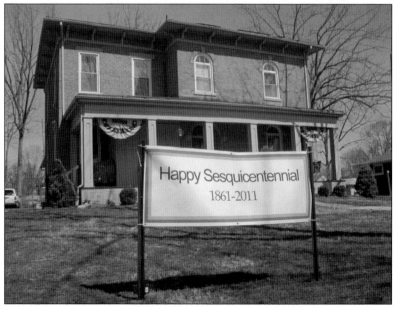

Pictured above is another view of the Kinnaird residence as it sat on Maple Drive in 1930. The road, which had previously served in past decades as the private driveway for the Kinnaird family, was later renamed Maple Drive when the area become New Rome in the 1940s. The street got the name because it was planted with maple trees when the Kinnairds initially lived on the grounds. The Prairie Township administration building, in addition to a satellite office for the Franklin County Sheriff's Office, would later be erected along Maple Drive. (Both, courtesy of the Southwest Public Libraries.)

Here, boys and their dog ride bikes down Gregg Avenue in the 1930s, before the road was renamed Beacon Hill Drive. They are approaching the intersection of Maple Drive, and one can see the gravel roads have yet to be paved. (Courtesy of the Southwest Public Libraries.)

Catalpa trees line Maple Drive in far West Columbus, as seen here in 1935. The stretch of Maple Drive from West Broad Street to Beacon Hill Drive is not aligned with the rest of Maple Drive, because, around 1856, it served as the private driveway for farmer James Kinnaird. The second road north of Broad Street is Kanard Avenue, named after the Kinnaird family, although misspelled. (Courtesy of Nola Freeman.)

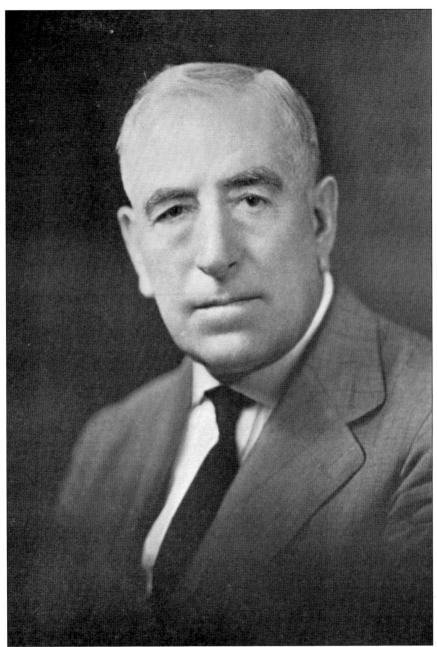

Simon B. Winters was a medical doctor who operated his practice in the Briggsdale neighborhood. Winters was commended for the actions he took during the great flood of 1913 when he rescued 1,500 people who were marooned on rooftops and stuck up trees in the Highland West area. Winters heard about these residents being trapped. He decided to quickly build a makeshift boat and then paddled through 2,000 feet of rushing waters to reach the people, putting him in harm's way in the process. He treated 407 residents for injuries on site, which equaled about a fourth of the population of 1,500 residents who lived in that area. Winters was praised for his fast response, in what otherwise could have been worse injuries for the wounded. (Courtesy of the Columbus Metropolitan Library.)

Karl Thomas Webber's family emigrated from Whales around 1850 and built their 14-room estate, pictured on the left, at its former location at 2585 West Broad Street. It was demolished after World War II to build a gas station. The family owned land on the Hilltop bordered by the National Road to the north, Sullivant Avenue to the south, Eureka Avenue to the east, and Ogden Avenue to the west. In June 1897, Webber graduated from The Ohio State University with a bachelor of laws degree. He served as prosecuting attorney for Franklin County from 1905 to 1911 and was the member of Knights of Pythias, Odd Fellows, Scottish Rite Masons, Shriners, and Phi Delta Phi. (Both, courtesy of the Columbus Metropolitan Library.)

One of the early homes built on Maple Drive during its development belonged to the Datz family. The residence at 33 Maple Drive was the residence of Al and Dorothy Datz sometime in the 1930s, when the community began to flourish and expand in population. (Courtesy of the Southwest Public Libraries.)

Pictured here is the Clime family's main farmstead, which was formerly located just south of the Hilltop, where Clime Road now exists. The family moved from Pennsylvania in the 1820s and first lived on South High Street, but the soil there did not prove good for farming. A few members of the Clime family even helped build the first Broad Street bridge. (Courtesy of Bonnie Bell.)

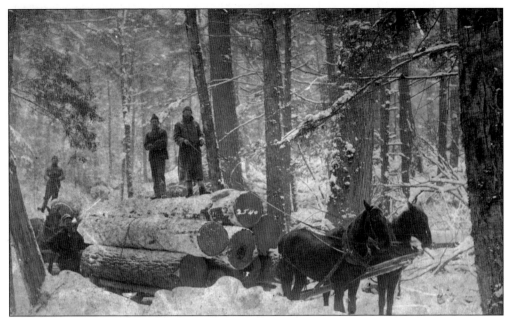

In the winter months, members of the Clime family cut down trees and hauled the wood away for burning material. In this photograph, L.C. Clime pulls a wagon of lumber from the south woods of his property in 1900. This land is now part of Big Run Park. (Courtesy of Bonnie Bell.)

Pictured seated on a bench outside their farmstead are John Herbert Woleslagel and Hylon Lydia Clime. Hylon was the daughter of Lester and Lydia Clime and were among the last generations to reside in West Columbus before buying land and moving to Union County near the mid-19th century. (Courtesy of Bonnie Bell.)

Arthur Boke Jr. was the first African American born in Franklinton in 1803. He was abandoned at birth, but then fostered by Sarah Sullivant, wife of Lucas Sullivant. She found Boke a few days after giving birth to her own child and saved him from death by starvation. When he died in 1841, Boke was buried with the Sullivant family in Franklinton Cemetery. When the family plot relocated to Green Lawn Cemetery, pictured on the right, Boke's grave was included, which was unprecedented at the time. In 1998, a bronze statue was erected, pictured below, titled "Celebration of Life." It honors not only the life of Boke but also the compassion and empathy Sullivant family had for the orphan. (Both, courtesy of Bea Murphy.)

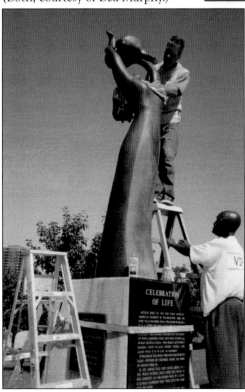

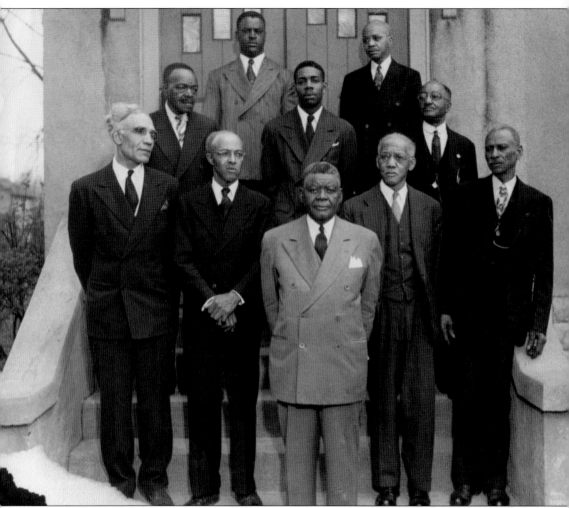

Rev. Jacob Ashburn Jr. was born in 1877 into a large family in Bowers Hill, Virginia. His parents, Jacob and Penelope Ashburn, were former slaves. His father fought as a cavalryman in the Union army during the Civil War. Although his family came from humble and rough beginnings, many of them achieved great things. The majority of them received an education; Ashburn attended Mount Union College in Ohio, Hillsdale College in Michigan, and Virginia Seminary in Lynchburg, Virginia. He came to West Columbus after being called upon to serve as pastor of a local Baptist church. Ashburn can be viewed above, standing alongside deacons from the Oakley Baptist Church. Ashburn is remembered as "the preacher who walked the streets of the Hilltop." (Courtesy of the J. Ashburn Jr. Youth Center.)

Rev. Jacob Ashburn Jr. remains a pivotal role model for African American youths. In addition to being the pastor of the Oakley Avenue Baptist Church from 1917 to 1955, he was also the first black man to deliver a baccalaureate sermon at West High School and one of the first African Americans to serve in the Ohio legislature from 1942 to 1943. (Courtesy of the Columbus Metropolitan Library.)

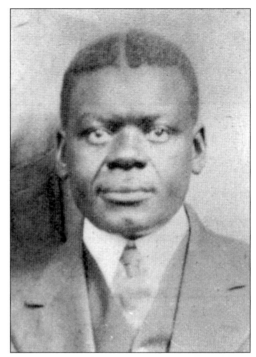

Pictured far right is Keith Neal, who, in later years, became the executive director of the J. Ashburn Jr. Youth Center after the passing of Jaymes Rehtta Saunders. He first joined the youth center as a janitor more than 30 years ago but became heavily involved with the organization. While Saunders handled the business side of the center, Neal performed grassroots efforts to interact with the community. (Courtesy of the J. Ashburn Jr. Youth Center.)

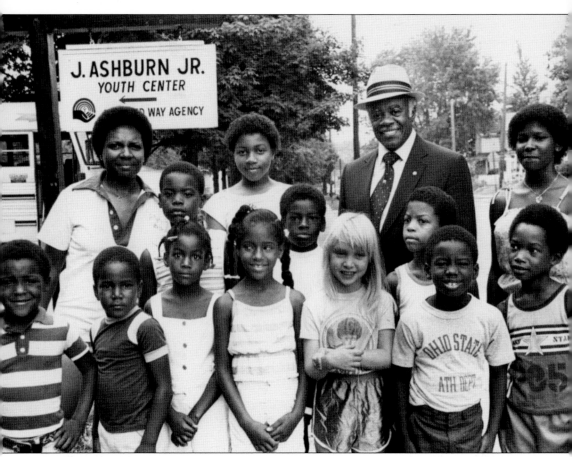

Jacob Julian Ashburn, pictured far right, was the son of Jacob and Virginia Ashburn. He followed in his father's footsteps of ministry at a young age. He took over as pastor of the Oakley Baptist Church following the passing of his father in 1955 and later founded the J. Ashburn Jr. Youth Center in honor of his father's passion for bettering the community. Jacob grew up on the Hilltop, graduated from West High School, and then served in the US Army. After his time in the military, Jacob mirrored his father in another way, by excelling in academia. He received degrees from The Ohio State University, Capital University and the Virginia Seminary. He also attended graduate school in California, where he served as a youth pastor. (Courtesy of the J. Ashburn Jr. Youth Center.)

Jaymes Rehtta O'Neal moved to the Hilltop neighborhood with her family in 1944. She had a knack for business and even graduated from The Ohio State University in only three years. She would become one of the three key players in creating the J. Ashburn Youth Center, which was created to foster a sense of community for local youths. Below, the basketball team at the J. Ashburn Jr. Youth Center travel to one of the away games. Prior to having its own facility, the youth program started at Oakley Baptist Church. When Jacob Julian Ashburn Jr. saw the impact they were making, he decided to expand the program, which would inspire youths to be useful, productive participants in American society. (Both, courtesy of the J. Ashburn Jr. Youth Center.)

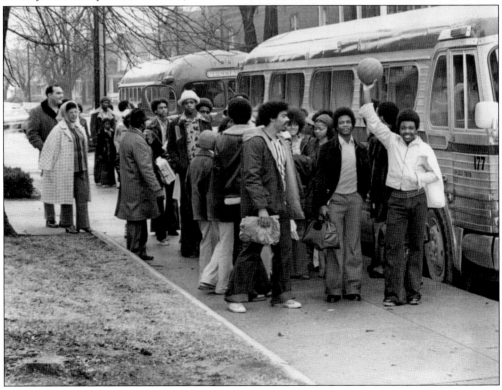

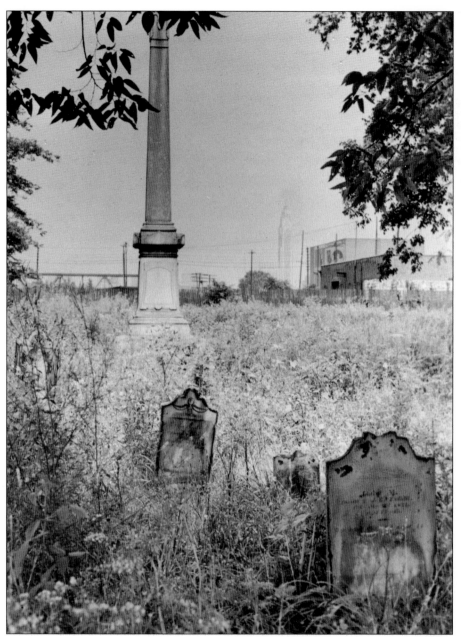

Franklinton Cemetery was established on River Street, just off Souder Avenue, in 1799. It was nestled in a locust grove through the mid-1800s on land Lucas Sullivant donated to be used for a church and public cemetery. This was the resting place of many early settlers, until abandoned in the 1870s. The church was also abandoned during the War of 1812, due to Franklinton being utilized as a recruitment and training center. The church was then converted from a place of worship to a facility that housed grain and supplies for the military. All that remains on the site nowadays are a number of crumbling headstones and a 26-foot obelisk to commemorate the first church. Other settlers were buried in private family plots that are scattered around West Columbus. Following the creation of Green Lawn Cemetery in 1848, most of the family plots from Franklinton were relocated to Green Lawn. (Courtesy of the Columbus Metropolitan Library.)

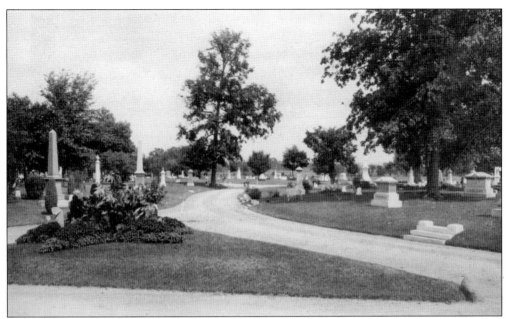

Pictured above is the east entrance to Green Lawn Cemetery in 1909. The city was growing faster than it could accommodate grave space. In 1848, a group of men created the Green Lawn Association and approached early settler Mary Wharton about her donating some of her land to use for the new cemetery. Amongst the notable people who are buried in Green Lawn Cemetery include five Ohio governors, Lucas Sullivant and his family, humorist James Thurber, restaurateurs Max and Erma Visocnik, businessman Samuel Bush (grandfather of former president George H.W. Bush), Rev. Thomas Woodrow, P.W. Huntington (founder of Huntington National Bank), reformer Washington Gladden, aviator Cromwell Dixon, and actor Grant Mitchell. (Both, courtesy of the Columbus Metropolitan Library.)

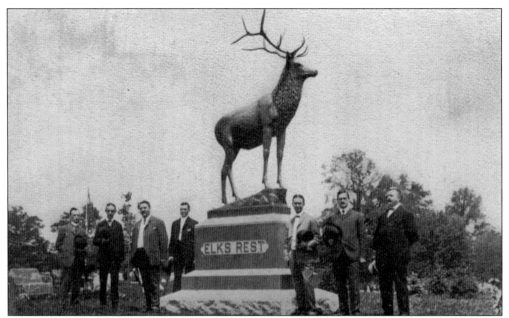

One of the many monuments within Green Lawn Cemetery is the Elks Memorial, built around 1900 by Salem resident William H. Mullins to remember those from the fraternal order who had passed away. The sculptor also created the Christopher Columbus statue at the Ohio Statehouse a half-decade later. (Courtesy of the Columbus Metropolitan Library.)

Elise Vanderberg (right of center, with her hands on the young boy's shoulders) is pictured with other members of the Clime and Vanderberg family in the early 1900s. The three prominent families of the Climes, Briggs, and Vanderbergs were all related through marriage since Conrad Clime moved to the area in 1833. The family also helped build the first Union Methodist Episcopal Church around the time of their arrival. (Courtesy of Bonnie Bell.)

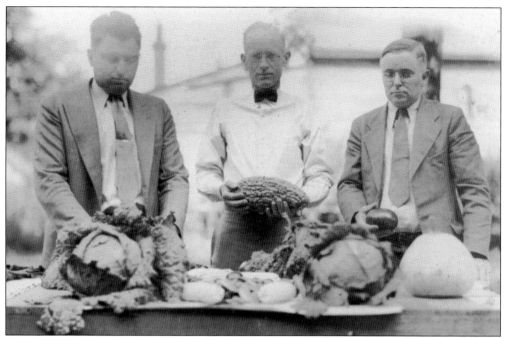

Edward Clime, pictured far right, showcases vegetables at the Ohio State Fair sometime around 1930. He was born in 1893 and had a twin brother, Charles, who died soon after birth. Edward was the last Clime to own the family home until he sold it to the city in the 1950s; the land was turned into the present-day Big Run Park. (Courtesy of Bonnie Bell.)

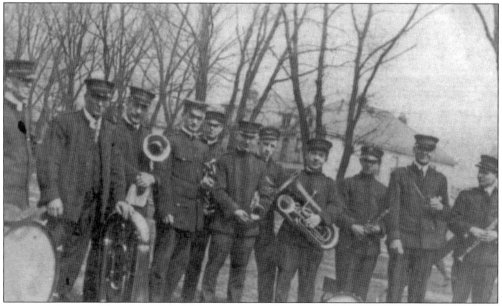

Amongst the members of the Hilltop Band, pictured here, was Edwin P. Barnes. He arrived to the present-day Westgate neighborhood around 1918 and worked for a local telephone and telegraph company where his job would have been to test international lines. The first intercontinental phone call was heard out of the Postal Telegraph-Cable Co. (Courtesy of the Westgate Neighbor Association/Joanne Horn Hylton.)

Burnside Heights was a small neighborhood created in 1907, when business partners Thomas Burnside and Charles Druggan pooled together funds and bought 27 acres of land from M.L. Sullivant's subdivision of farming lands. Pictured here is the Burnside School building, located behind an alley near Eakin Road. The community was one of the first African American neighborhoods in the city. In many ways, the small community was self-sustaining. When it was first established, there were only a few small homes on the land. Over the years, it expanded to not only add more residences, but the neighborhood established its own church and school, and even a number of small stores sprung up within walking distance of residents by the 1950s. One of the shops, Collins Store, was popular amongst the children for its candy and soda. It was demolished 10 years later to erect another home. (Courtesy of Bea Murphy.)

Two

CAMP CHASE
LEGACY OF THE CIVIL WAR

In December 1862, Union colonel William Knauss was left for dead in the field of battle at Fredericksburg. The facial wound he received exited through his lower extremities leaving him unable to return to military action.

Six years later, he traveled through Virginia and North Carolina and his guide was an ex-Confederate soldier who had fought in the same battle, which resulted in him losing a leg. The two former soldiers came to terms through conversation and reached a gentleman's agreement: they would promise to always commemorate the deaths of soldiers who paid "the ultimate sacrifice," no matter what side they fought on.

Thirty years later, in 1893, Knauss moved from his New Jersey residence to West Columbus. When he discovered the Camp Chase Confederate Cemetery, located on a dirt road known as Sullivant's Free Pike, where more than 2,000 Confederates were laid to rest in a communal grave, he would later write he was unhappy with the state of the cemetery grounds.

Camp Chase began as a Union army training camp but shifted to a prisoner-of-war camp early in the war. By the time the war ended, more than 100,000 Union soldiers and 200,000 Confederate soldiers had passed through the grounds.

Thousands of Confederate officers were brought to the camp following victories at Fort Donaldson, Tennessee, on February 16, 1862, and at Mississippi Island No. 10 on April 8, 1862. The prison held 8,000 men by the next year. Over the next two years, more than 2,000 men died in result of the harsh winters, malnutrition, and a smallpox epidemic.

Knauss hired local farmer, Henry Briggs, the sum of $25 per year to help care for the cemetery and, in doing so, honor the promise he made years previous. The two men cleared the overgrown brush, laid new headboards along the gravesite, and erected a stone wall around the perimeter of the cemetery, which still stands today.

In 1895, he planned the first memorial service for the fallen Confederates, which fell through due to sensitivity around the event. Knauss continued his efforts though, and by 1897, nearly 1,500 people attended the memorial.

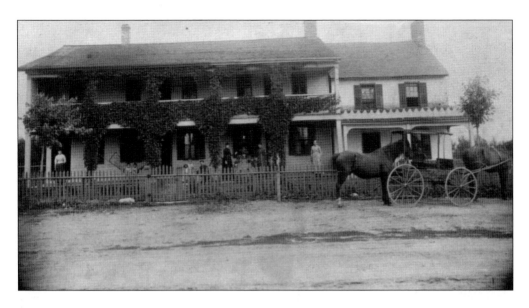

Union officers and visitors to Camp Chase would frequent the Old Four Mile House Tavern & Inn as a meeting headquarters during the Civil War. It was located just across the road from the training camp. It was also a popular destination for travelers making their way across the National Road. Innkeepers Timothy and Hannah Bigelow opened the stagecoach stop on February 14, 1863. Pictured below is another angle of the Old Four Mile House, with a few patrons relaxing on the front porch. Prior to its demolition around 1913, Four Mile was located on West Broad Street. (Both, courtesy of the Columbus Metropolitan Library.)

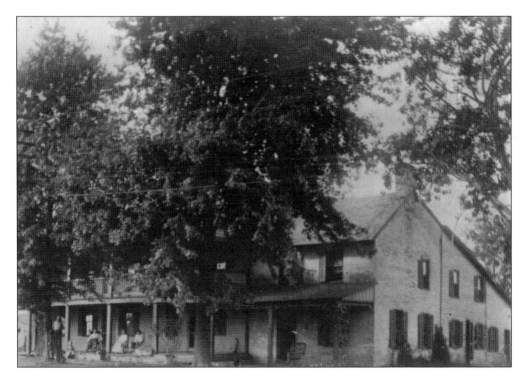

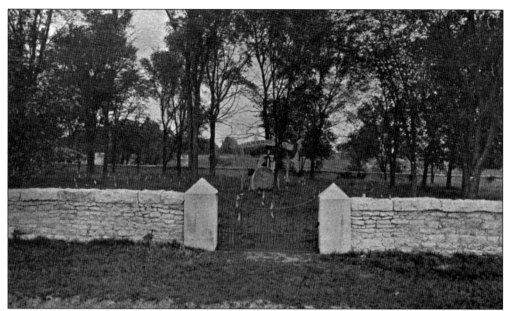

Military officials stopped burying the bodies of Confederate prisoners at the city cemetery in 1863. Instead, they created a communal grave near Camp Chase. After the United States closed the prison, the government continued to lease the two acres of cemetery property. In 1879, the US government purchased the land. Congress appropriated funds to build the stone wall around the cemetery in 1866. Camp Chase officially closed in 1865, and within two years, most of the 160 wooden structures between West Broad Street and Sullivant Avenue, from Hague Avenue to the railroad tracks, were taken down. Most of the structures had come from the dismantled Camp Jackson, located near present-day Goodale Park. Catherine Pemberton's residence at 57 South Hague Avenue was one of the cottages that survived following the Civil War. (Both, courtesy of the Columbus Metropolitan Library.)

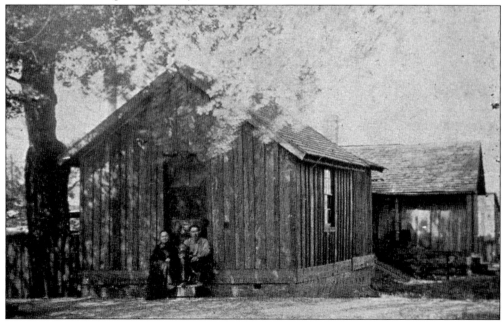

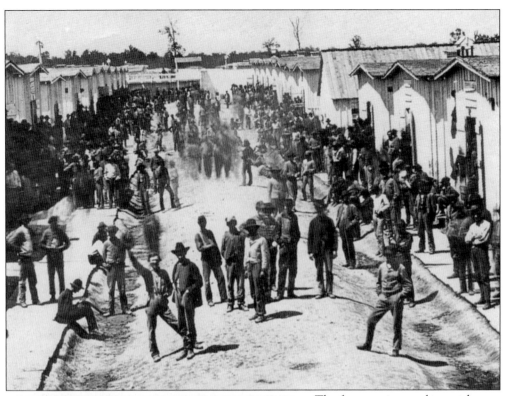

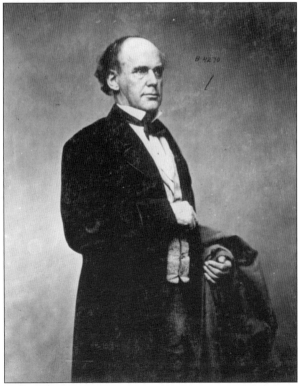

The famous picture above, taken by M.M. Griswold, is of Prison Camp No. 3 during a visit to Camp Chase around 1865. Confederate prisoners were housed in small wooden structures, which measured 20 feet by 14 feet. There was not much room either, since about 18 men were kept in each building. Camp Chase was named after Salmon P. Chase, pictured on the left, who became Ohio's first Republican governor in 1855. He lost the presidential bid to Abraham Lincoln a few years later but served as secretary of treasury under Lincoln's regime. Chase was perhaps best known for his civil rights involvement and banking innovations. (Both, courtesy of the National Archives, Washington, DC.)

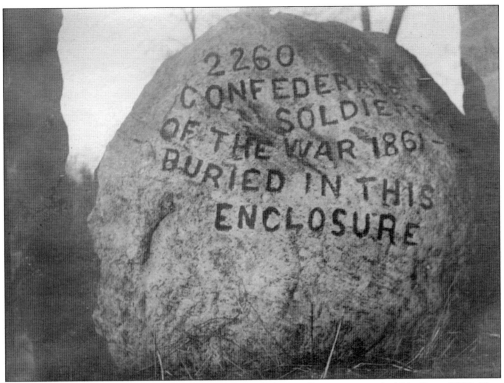

The first memorial service for Camp Chase Confederate Cemetery was held in June 1896. Two memorials were installed in the cemetery at the turn of the 19th century. The Camp Chase rock was first placed there and reads, "2260 Confederate soldiers of the war 1861—buried in this enclosure." A permanent arch was later erected and dedicated on the site on June 14, 1902. (Courtesy of the Columbus Metropolitan Library.)

For years, residents thought the soldier monument that sits on top of the memorial arch was bronze, but during a later restoration of the statue, they discovered it is actually forged from zinc. The wooden arch the statue originally stood atop was replaced with a 17-foot-tall stone arch in 1902. (Courtesy of the Columbus Messenger Newspapers.)

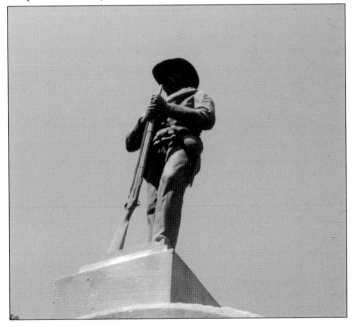

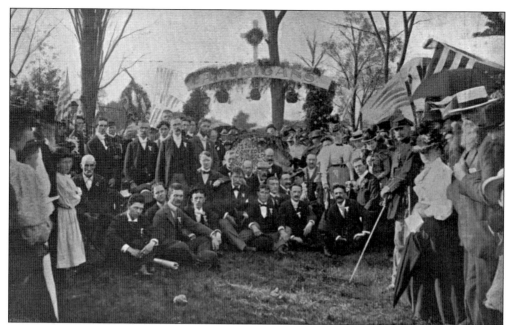

The Confederate Glee Club from Louisville, Kentucky, attended the Camp Chase Confederate Cemetery Memorial on June 4, 1898, with former Tennessee governor Robert Taylor. The *Press-Post* and *Columbus Dispatch* both reported peace within the crowd of 4,000 visitors and letters from ex-Confederate soldiers were read in thanks. The memorial was organized by the Daughters of the Confederacy starting in 1902 and, later, by the Hilltop Historical Society in 1995. The descendant of Salmon P. Chase, a local resident and historian named Monty Chase, has helped organize the program over two decades since the historical society took control. Monty, along with his late wife, Margaret, is pictured below. (Above, courtesy of the Columbus Metropolitan Library; below, courtesy of the author.)

Three

LAND USE
TRANSITION FROM
FARMLAND TO SUBDIVISIONS

From the far west community of Rome to the first settlement of Franklinton, the majority of the land in what is present-day West Columbus was utilized for farming. Even today, residents can find pocket farms selling eggs, garden vegetables, and other perishables along corridors like Harrisburg Pike and West Broad Street.

Between the years 1804 and 1888, Lucas Sullivant sold or gave away 1,600 acres of land to his sons Joseph Starling and Michael and in doing so created Sullivant's Hill, as it was above the river level. Michael also purchased other properties and acquired 5,000 acres of farmland by the 1830s and formed M.L. Sullivant's subdivision of farming lands.

In 1854, he sold all his property and relocated to Illinois. This included the 160 acres purchased by John Holloway prior to the Civil War and leased to the Union for the establishment of Camp Chase. It also included around 27 acres that was bought in 1907 to create one of the first area African American subdivisions, Burnside Heights.

When the US government abandoned the Camp Chase grounds following the war, the land went up for auction. Members of the Short Creek Quarterly Meeting of the Quaker Church heard about an opportunity to acquire 463.5 acres, which encompassed Camp Chase and other areas on Sullivant's Hill. Five men decided to purchase the land on January 23, 1872.

Quakers J.C. McGrew and Robert Hague purchased 80 acres each; Miller Gibson and William Binns each purchased 100 acres; and John Watson purchased 40 acres. Two years later, John Hussey grabbed the remaining 63.5 acres. They were later joined by other Quakers, like William H. Harris, John Watson, Lewis Ong and John Cowgill; these families inspired the names of many present-day Hilltop streets.

The railroads brought industry to West Columbus, and the introduction of streetcar systems enabled families the chance to fulfill the American dream of owning a home, thanks to affordable transportation. This attracted realty companies that wanted to transform the vast farmlands into subdivisions starting in the late 1890s.

Pictured above is the home of prizewinning Holstein breeder William B. Smith, owner of W.B. Smith & Sons. The photograph is of his residence at 2456 West Broad Street, which stood near the Columbus State Hospital for the Insane around the year 1900. Pictured below is Smith's heard of cattle, which won numerous awards at the Ohio State Fair and similar events during the early 1900s. W.B. Smith & Sons sold cattle to farmers across the country, and the name carried a reputation for breeding Holsteins that were not only beautiful creatures but were also amongst the best dairy producers. (Both, courtesy of the Columbus Metropolitan Library.)

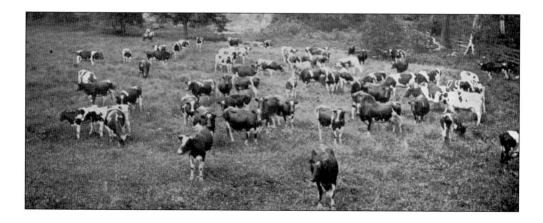

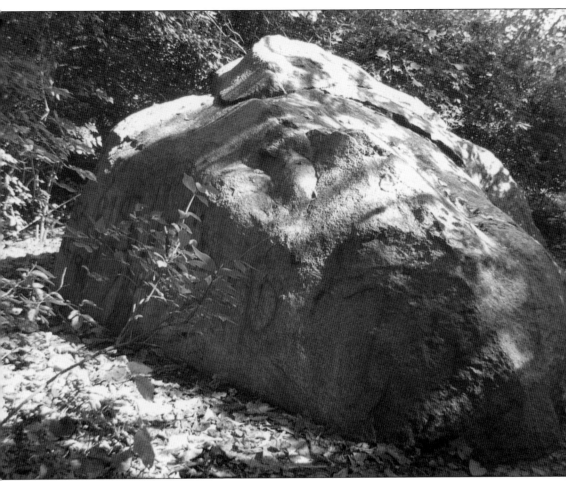

The Franklinton community held its centennial celebration over two days, starting on September 14, 1897. Local officials held the event between Wheatland Avenue and Whitethorne Avenue, near the Columbus State Hospital. The boulder, pictured above, measures 51 feet in circumference and was once painted in homage of the first settlement. During the celebration, tents were set up near the boulder, and there were games of skill and lemonade stands. Everyone noticed the boulder, which sat at the center of the grounds. The residents decided that the boulder was a good symbol for their community since it has withstood time, weather, and disasters. They viewed their community in similar fashion. (Courtesy of the Columbus Metropolitan Library.)

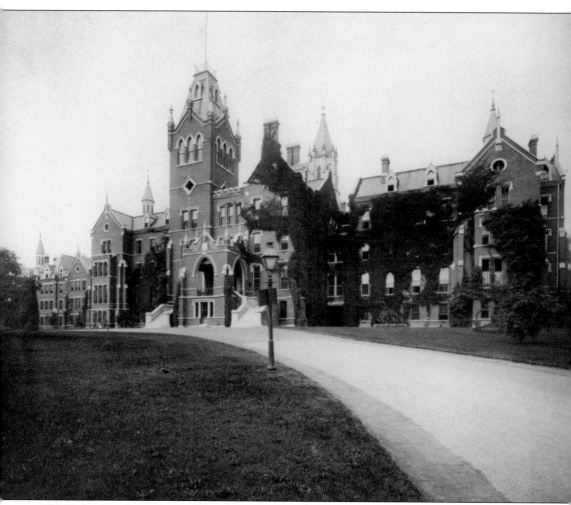

The Columbus State Hospital for the Insane at 1960 West Broad Street is one of the earliest examples of how land use in West Columbus could be used for more than farming. It was originally the Lunatic Asylum of Ohio when built through convict labor in 1838, but a fire destroyed the facility in 1868, killing 6 patients and displacing 314 others. Ohio legislatures authorized the construction of a new asylum. After seven years, the $1.5 million project was completed in 1877. The hospital could hold 850 patients but had about 1,300 by the year 1900. The hospital remained in service until the late 1980s, until its degenerating conditions warranted it to be demolished in 1997. It was replaced with a new Ohio Department of Public Safety and Transportation facility. The hospital has also gone by other names over the years, including Central Ohio Lunatic Asylum, Central Ohio Hospital for the Insane, and the Central Ohio Psychiatric Hospital. Patients who died while in the staff's care were buried in four on-site cemeteries that remain there today. (Courtesy of the Columbus Metropolitan Library.)

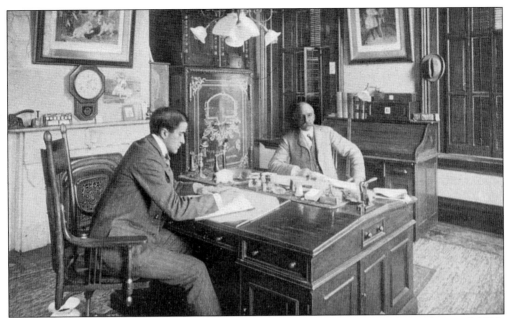

Pictured above are two men in the steward's office at the Columbus State Hospital around 1900. The administrative offices were elaborately decorated with electric hanging lights, paintings, and wood paneling. Staff included doctors and academic physicians; many of the full-time staff lived on the hospital grounds with their families. (Courtesy of the Columbus Metropolitan Library.)

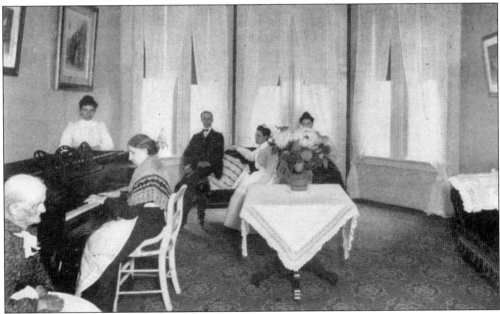

Patients in the women's ward at the Columbus State Hospital listen quietly on as another patient plays the piano. The hospital staff furnished the room with curtains, flowers, and tablecloths to make the facility feel more comfortable for the elderly who had to reside there due to lack of family or were given away to the state by families who were unable to provide round-the-clock care. (Courtesy of the Columbus Metropolitan Library.)

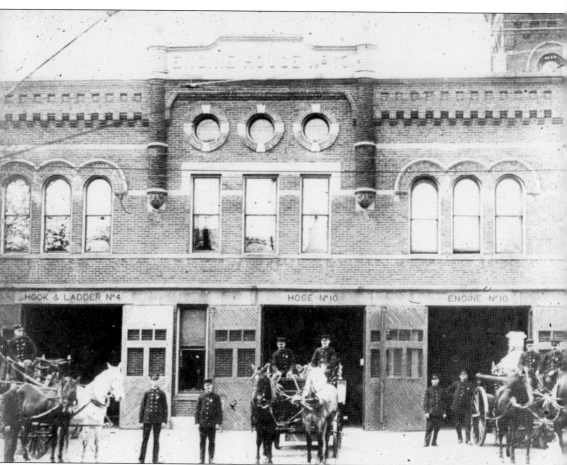

As the oldest active firehouse in the city, Engine House No. 10 holds historical significance for many residents. Its construction began in August 1896 and was finally completed by February 1897. In 2008, the Columbus Division of Fire moved to an adjacent lot, from 1096 West Broad Street to 1080 West Broad Street, but the old engine house still stands today. Other historic fire stations in West Columbus included Chemical House No. 1, which was completed a year later in 1897. This was the fire station that held all the African American firefighters who were relocated from the Oak Street Station. The Chemical House operated from its location at 2105 West Broad Street in the Hilltop neighborhood until 1912. Racial diversity in the city fire department was a hot topic during the time and still remains a controversial issue today. (Courtesy of the Columbus Metropolitan Library.)

On July 7, 1910, the Columbus Baby Camp opened its doors for the first time to serve underprivileged youth. It operated from 1725 Sullivant Avenue, near Helen Street. Its staff provided nutritional meals, clean environments, and nursing care for infants and toddlers. Nurses Catherine Tuttle and Augusta Condit cofounded the project. (Courtesy of the Columbus Metropolitan Library.)

The Friends Rescue Home, located on North Harris Avenue, was a charitable organization that provided a home for wayward girls and unprotected children. The group gave food, clothing, and shelter to unwed mothers and at-risk children. The home was first founded under the name Rescue Home for Girls in 1904. (Courtesy of the Columbus Metropolitan Library.)

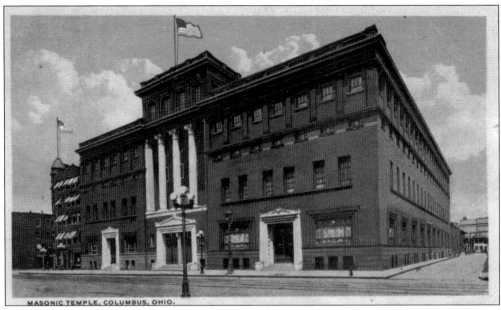

MASONIC TEMPLE, COLUMBUS, OHIO.

The West Gate Masonic Lodge was first chartered on October 23, 1913, and still operates out of its building at 2925 West Broad Street. The lodge chapter is part of the Fourteenth Masonic District and remains active in the West Columbus community. The group is dedicated to public service and community outreach. (Courtesy of Hope Moore.)

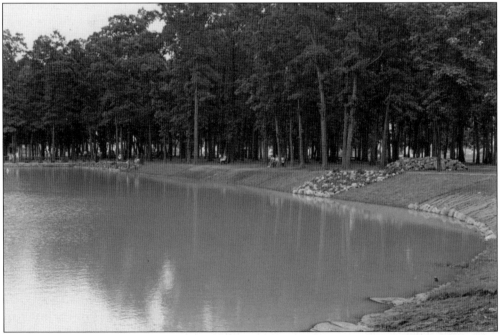

Westgate Park looked vastly different in 1939. The natural pond, referred to as Harder Lake, has always served as a popular fishing spot for families and young children during summer months. The above photograph shows the pond before the concrete basin and the park grounds were thicker with white oak, red oak, hickory, willow, walnut, ash, and elm trees. (Courtesy of the *Columbus Citizen*/Scripps-Howard Newspapers/Grandview Heights Public Library/Photohio.org.)

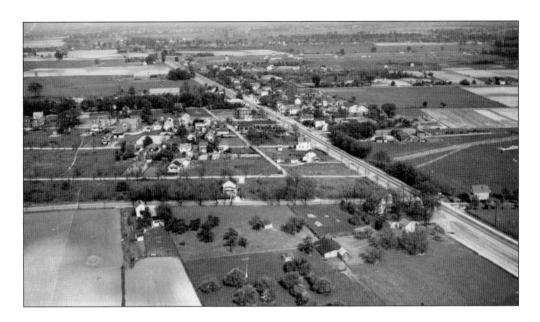

Above is an aerial shot of the Rome area in the 1930s along the National Road. The vacant land in the upper left-hand corner is where the Lincoln Village neighborhood would later be developed. The community was renamed New Rome when incorporated in 1947. The village dissolved in August 9, 2004, due to election misconduct and police scandal. Pictured below are residents gathered to celebrate the Rome area's centennial on July 4, 1936. The first settlement of this neighborhood had 64 lots, which included 32 lots on each side of the National Road, also known as West Broad Street. (Both, courtesy of Nola Freeman.)

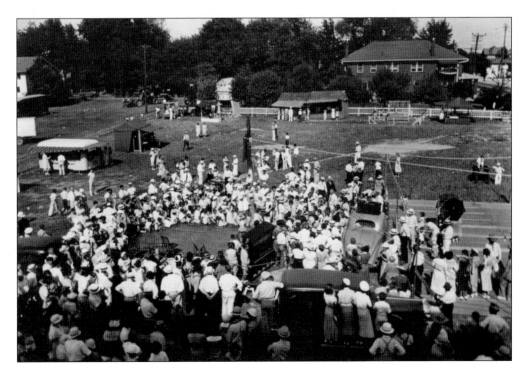

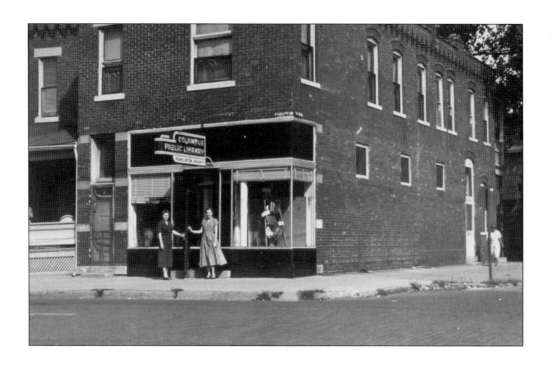

The Franklinton Branch library was located on 840 Sullivant Avenue between the years of 1943 and 1976. A new facility was relocated to 1061 West Town Street a few decades later. Its ground breaking was on April 27, 1994, followed by a dedication ceremony held on January 25, 1995. Below, the Hilltop Library has a long history that started in 1911, when the Sunset Literary Club received 300 donated books it collected inside West Broad Elementary School. Ten years later, a man named Lawrence Holmes donated his private book collection, and the library was moved to the second floor of the Hilltop Branch of the Citizens Trust & Savings Bank. As the Columbus Public Library expanded, it acquired the Holmes Library and started the first Hilltop Library at 21 North Hague Avenue in 1928. It stayed there for 22 years until the library located once more in 1949 to 2955 West Broad Street; it then moved one last time in 1996 to its present location on at 511 South Hague Avenue. (Both, courtesy of the Columbus Metropolitan Library.)

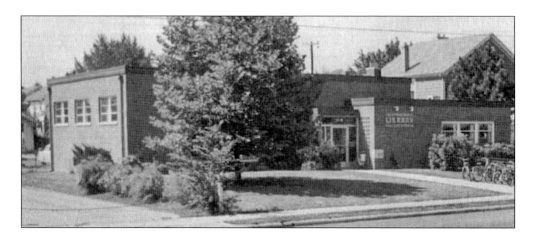

From left to right, Rome residents Hilda Walz, Frieda Anderson, and Marjorie Lamb have some fun celebrating along the West Broad Street corridor during the Rome Fire Department parade in 1950. The annual Fourth of July parade was taken over by the Westland Area Business Association years later, and it still continues today; although, the former community it once took place in no longer exists under the name of Rome. Today, the parade takes place in Westland. (Courtesy of the Southwest Public Libraries.)

Santa Claus arrives at Westgate Park on a float during the 1950 Christmas parade. During the holidays, houses on every street had Christmas lights and yard ornaments. Today, the Westgate community has annual decorating contests. The second-most celebrated holiday in Westgate has always been Halloween. In addition to the usual trick-or-treaters, the neighborhood associations have partnered with schools to offer fun games and family-friendly events. A favorite of Halloween carnival is Boo-at-Binns, hosted by Binns Elementary School each year; residents also enjoy competing for who has the scariest Halloween decorations. (Courtesy of the Westgate Neighbor Association/Elizabeth Hylton.)

Four

NATURAL DISASTERS
SURVIVING THE FLOODS

It would be difficult to talk about the region of West Columbus and not mention its long history of natural disasters. In 1798, settler Lucas Sullivant abandoned the 220 lots he platted a year earlier and moved Franklinton, just short of a mile east, due to a flood caused by the Scioto River.

Sullivant nicknamed the community "the Bottoms" because it is situated below water level and bordered north and west by the Scioto River. While this location produced the best soil for farming, the abundance of rain would cause the river to spill over into the dirt roads and drown crops, so the community built wooden levee to keep back the water.

Throughout the first settlement's history, there were three major floods that devastated the region: the floods of 1898, 1913, and 1959. The greatest of these floods was in 1913, which cost the city $22 million in damages. This event also spurred the country to look closer at watershed planning and flood control.

Columbus finally began construction of a $193 million flood wall about 30 years after the flood of 1959. Its construction was finalized in 2003.

Until 1929, the Columbus Division of Police was also based out of Franklinton. During the spring of that year, a F3 tornado rampaged through West Columbus. The end result was the construction of a new police headquarters in downtown Columbus, and Franklinton lost one of the last bases of government that had remained within its borders.

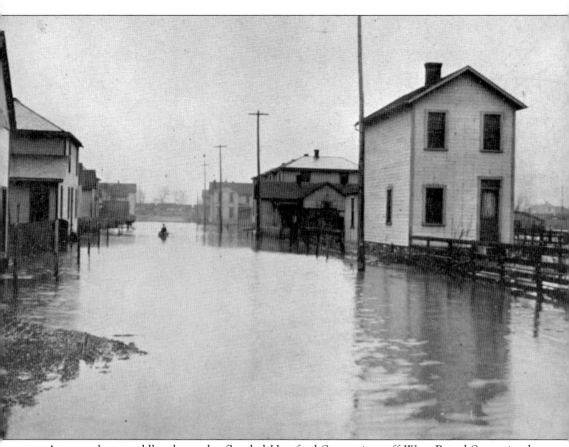

A rescue boat paddles down the flooded Hartford Street, just off West Broad Street in the Franklinton neighborhood. Prior to the flood of 1913, the worst flood experienced by West Columbus was the flood of 1898 that left the Franklinton neighborhood swimming in 10 feet of water between the days of March 23–24. The Scioto River tributaries were already at a high level, so heavy rain resulted in the levee breaking and water overflowing in every direction. The river passed about 75,000 cubic feet of water per second, flooding 800 acres of West Columbus. The flood caused many factories to close down due to invading waters, and by midnight, the city's blast furnace was quenched and residents were left in darkness, as electricity was lost. The natural disaster displaced about 30,000 people throughout Columbus. (Courtesy of the Columbus Metropolitan Library.)

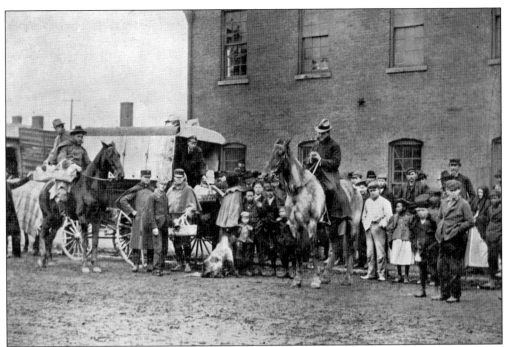

Dr. Frederick Gunsaulus and his relief corps members distribute food, dry clothes, and other goods to the victims of the flood of 1898. In the center is a dog named Joe, who reportedly saved the lives of a mother and two children during the disaster. (Courtesy of the Columbus Metropolitan Library.)

This is an early photograph of the Hilltop Exchange following the flood of 1913, which affected dozens of businesses in the Hilltop and Franklinton neighborhoods. This operated as the local telephone office for residents between the years 1911 and 1920. During that decade, it served as a main hub for communicating with friends and distant relatives. (Courtesy of the Columbus Metropolitan Library.)

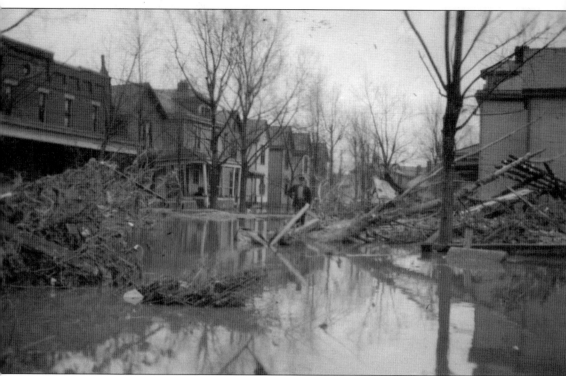

Water reached nearly 22 feet in some areas of Franklinton, when the Scioto River flooded into West Columbus starting on March 23, 1913. Over the span of four days, following the levee failure, floodwaters rushed through the community creating whirlpools and rapids that swept away people, cars, and even buildings. It was reported animals lay dead in the streets, nearly 100 people died, and 300 businesses were destroyed; the flood left 4,071 other businesses damaged. The flood of 1913 is the worst natural disaster to hit West Columbus, leaving more than 20,000 people homeless and another 15,000 prisoners to the second floors of their homes. The Hilltop neighborhood became a refuge to the residents of Franklinton, also known as the Bottoms, who were too low in elevation to escape the water. There were accounts of some people being forced to wait in trees or rooftops until the fire department could rescue them by boats. (Courtesy of the Columbus Metropolitan Library.)

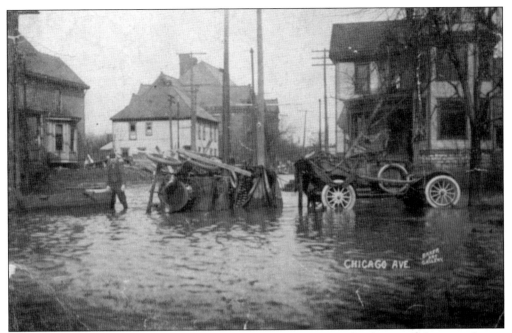

The man seen here is walking through knee-high water, pushing his boat to deliver supplies to neighbors along Chicago Avenue. Following the flood of 1913, many families were forced to dwell on their second floors until help arrived. Other families in one-floor homes were left displaced for weeks. (Courtesy of the Columbus Metropolitan Library.)

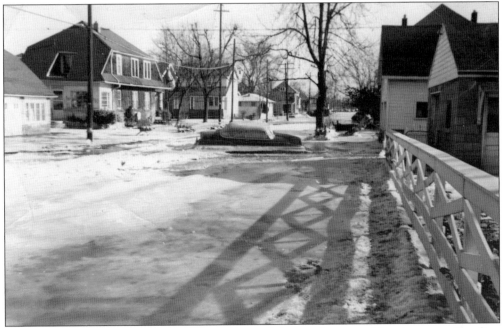

Pictured here is one of the many cars buried beneath layers of snow and freezing water. Flooding impacted more people this time than in previous eras because of the housing boom. While there was more damage and lives lost in previous years, the amount of people touched by flooding is more than when West Columbus was predominantly farmland. (Courtesy of Michelle Barr.)

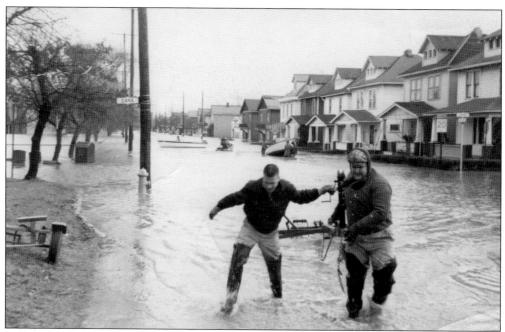

Residents pull equipment through floodwater at an intersection along Dana Avenue. On January 21, 1959, the second worst flood in the history of West Columbus struck when the Scioto River's levee broke due to record-breaking rain and frozen ice. Sixteen people were killed statewide during the three days the floods affected Columbus, Mount Vernon, Newark, and Chillicothe. Streets were three feet under water, 100 houses were damaged, and the Red Cross evacuated 3,200 people from their homes. The city began construction on a flood wall in 1993, which was completed by 2004. (Both photographs by Ray Midlick, courtesy of Michelle Barr.)

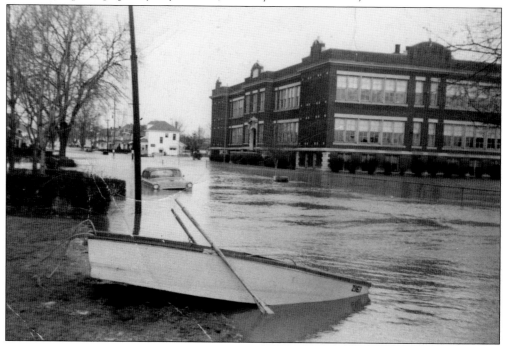

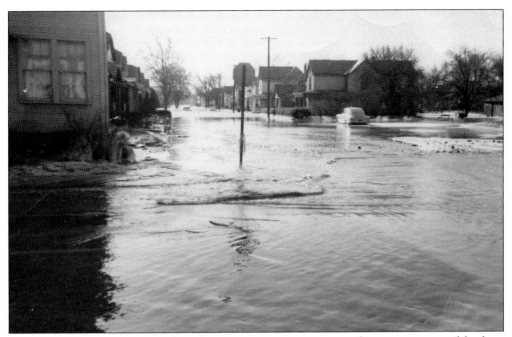

The water remained high enough in the streets to prevent motorists from getting around for days. Columbus finance director M.D. Portman estimated that the flood of 1959 caused $796,980 in damage to the city. The amount of infrastructure damaged made city officials ask Pres. Dwight Eisenhower to pay for the destruction caused during the flood. (Courtesy of Michelle Barr.)

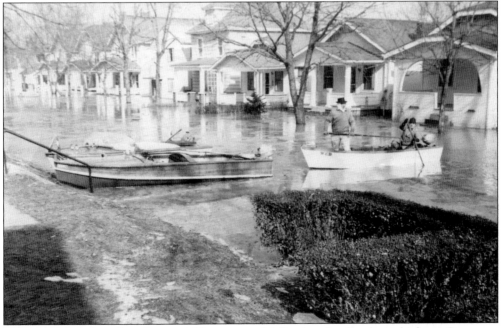

The only way a lot of residents could get around following the flood was by boat. Since not everyone owned a watercraft, those who did own boats would paddle down the roads to see who needed assistance. Residents also faced heavy snow on the ground and the January cold. (Courtesy of Michelle Barr.)

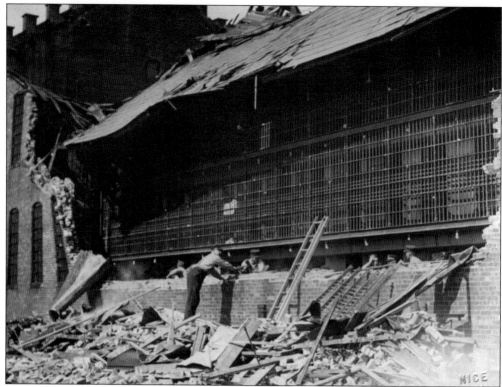

On May 2, 1929, a tornado struck Franklinton, and in its path was the Sullivant Avenue Workhouse, located at 515 Sullivant Avenue at the corner of McDowell Street, around what is today the Dodge Park and Recreation Center. Referred to as "the old workhouse," construction of the building began on January 26, 1896. The tornado is referred to as "the 1929 Rye Cove, Virginia tornado outbreak." Locally, it passed through West Columbus from the Galloway area to Franklinton. Its heavy winds leveled a gas station on its way to destroy the west portion of the workhouse, killing two men sitting in their jail cell. Officers stand with Patrol Car No. 1, pictured above, in front of the police headquarters at 515 Sullivant Avenue sometime in 1922, where Dodge Park and Recreation Center now exists. The building served as a jail starting on January 26, 1896, and as police headquarters from 1920 to 1930. (Both, courtesy of the Columbus Metropolitan Library.)

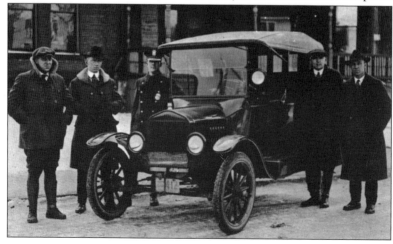

Five

TRANSPORTATION
TRAINS, STREETCARS, AND MOTORCYCLES

The railroad industry transformed Franklinton from a farming community into a hub for commercial activity when the first railroad system was built through its community in 1850. Interurban railways became a major form of transportation and attracted men looking for work from across the state and West Virginia.

The New York Central Railroad, Pennsylvania Railroad, and Baltimore & Ohio Railroad all would eventually shoot across West Columbus neighborhoods.

On April 23, 1872, a small upstart called Glenwood & Green Lawn Railway Company was formed by a group of men living on Sullivant's Hill including William Starling Sullivant, Robert Hague, W.B. Hawkes, and A.D. Rodgers, among others. They raised $50,000 in capital stock to get it off the ground.

They constructed a railway on Broad Street, also known as the National Road, from High Street to the Columbus State Hospital for the Insane. It also featured a branch running to Green Lawn Cemetery, byway of Glenwood Avenue to Mound Street south to Harrisburg Pike.

Ahead of its time, the city passed an ordinance in 1875 that forbid passengers from smoking in the streetcars. The railway company merged with Columbus Street Railway Company in 1892. These modes of transportation allowed for commuter neighborhoods to sprout up in West Columbus, like the Westgate area in the 1920s. Streetcar systems became widespread, and people could live farther from work.

It remained a popular form of transportation until the industry moved into the direction of trolleys and bus systems by 1948.

Railroads were also an important part of manufacturing. If not for railroads, supplies would be hard to deliver, and products would take too long to reach their destinations. The railroads transformed West Columbus once again into a manufacturing region.

In 1946, General Motors, called Fisher Body-Ternstedt Division at the time, built an expanded facility near West Broad Street and Georgesville Road. The Fisher Body Plant became a leading employer for the region and paved the way for an increase in automobile-related businesses to open in West Columbus, ranging from dealerships to body shops.

The National Road covers 700 miles from Maryland to Illinois. Its construction opened the Western part of the country to the movement of goods and produced many new settlements, including the former Rome area. The road influenced the types of businesses that popped up in the settlement to accommodate travelers, including taverns, inns, and blacksmith shops. (Photograph by Alan Jazak, courtesy of the Westgate Neighbor Association.)

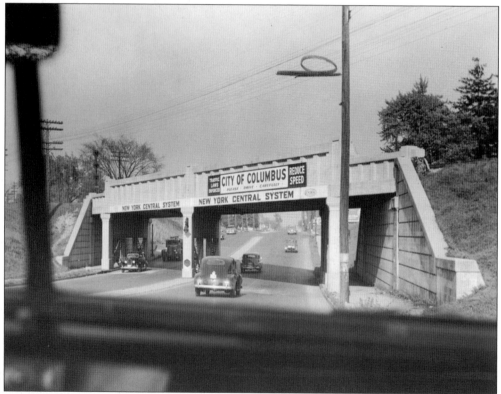

One of the railroads to pass over the 3400 block of West Broad Street in the Hilltop is the New York Central Railroad. It was formerly the Big Four route until New York City acquired it and the Toledo & Ohio Central Railroad (TO&C) station in the 1930s. The Big Four route was brought to West Columbus in 1889 and was constructed of tin material, which was rebuilt with concrete in the 1920s. (Courtesy of the *Columbus Citizen*/ Scripps-Howard Newspapers/Grandview Heights Public Library/Photohio.org.)

Pictured above is a view of the Big Four railroad tracks crossing along West Broad Street during the turn of the 19th century. A year after the Xenia Railroad was introduced into Franklinton, the Cleveland, Columbus & Cincinnati Railroad came through Columbus in 1851. It originally transported passengers between Cleveland and Cincinnati. (Courtesy of the *Columbus Citizen-Journal*/Scripps-Howard Newspapers/Grandview Heights Public Library/Photohio.org.)

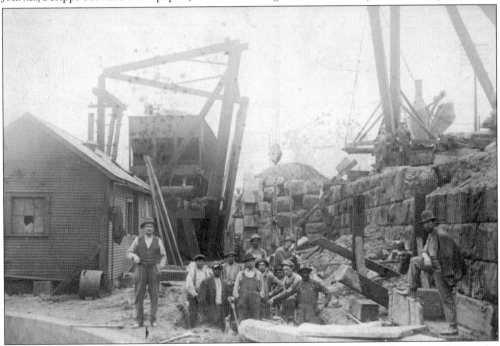

Foreman Chester Melvin Davis (far left) pauses for a photograph with his crew during the construction of the Mound Street bridge in the Franklinton neighborhood during the late 1800s. The bridge was damaged during the flood of 1898. Davis helped construct a number of bridges in Columbus, including also the Fourth Street Viaduct. (Courtesy of the Columbus Metropolitan Library.)

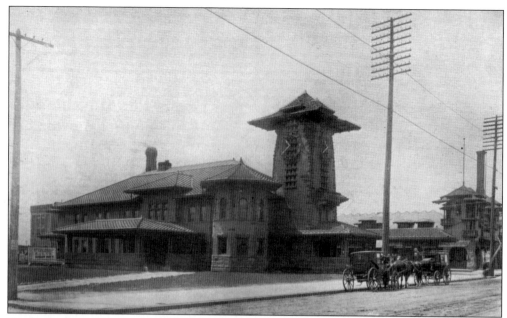

Two horse-drawn carriages are parked outside the Ohio Central Passenger Station at 379 West Broad Street in 1908. Also known as the Toledo & Ohio Central Railroad Depot, the facility opened on April 18, 1896, and closed down in 1930 to make room for the Volunteers of America Center. The station was designed by prominent Ohio architectural firm Yost and Packard. (Courtesy of the Columbus Metropolitan Library.)

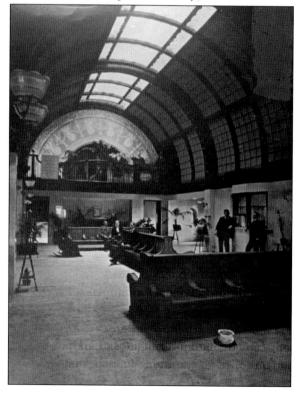

Pictured here is the interior of the Toledo & Ohio Central Railroad Depot. Passengers line the wooden benches of the facility's waiting room for their transit to arrive, which was overlooked by a balcony on the far wall that featured a skylight running the length of the room. (Courtesy of the Columbus Metropolitan Library.)

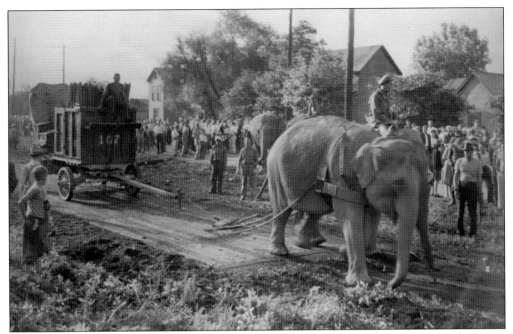

One day, in 1939, the train car was not hauling coal, but the load was just as heavy—elephants. Seen above, elephants pull a wagon filled with equipment from the railroad spur to Mound Street to prepare and set up the show grounds in West Columbus. (Courtesy of the *Columbus Citizen/ Scripps-Howard Newspapers/Grandview Heights Public Library/Photohio.org.*)

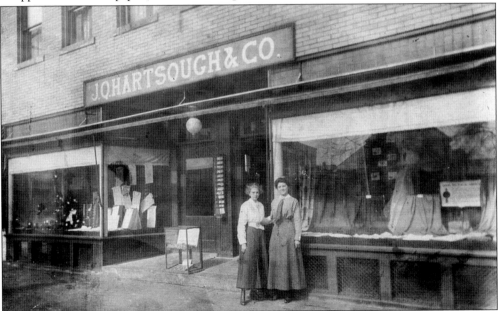

J.Q. Hartsough & Co. was noted by the *Railroad Trainman* journal as a supporter of the Brotherhood of Railroad Trainmen in 1909. Two saleswomen can be seen above standing outside their storefront at 1240 West Broad Street. The company was created by Junus Q. Hartsough and served as a dry goods and retail store, selling work clothes and supplies to local union members. (Courtesy of the Columbus Metropolitan Library.)

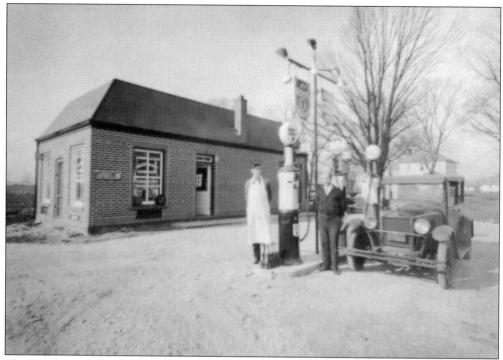

The Westgate Corner Confectionery was owned by brothers Othmar and Carl Isselstein at the corner of Sullivant Avenue and South Huron Avenue, pictured above in 1931. The family changed their name to "Stone" during World War II, and they still remain members of the community today; however, the independently owned convenience store no longer exists. Businesses like this popped up more as the region became more commuter based. (Courtesy of Steve Stone.)

Construction workers use a crane to remove debris along West Broad Street during its 1940 improvements. The National Road, also known as US Route 40, has always been embraced as part of the Rome area's historical identity. Prior to the population growth, the road was an important component in its economy. Many businesses catered to travelers during their journey along the National Road. (Courtesy of the Southwest Public Libraries.)

In the photograph above, a construction crew digs out trees and brush along West Broad Street during the fall of 1940, in preparation to replace the gravel road with asphalt. The improvements were needed to better the residential section of the Rome neighborhood, as the community began to grow and more cars began to use the roadway. Pictured below, the construction crew uses machinery to remove larger trees outside the Hammond Drugstore. As businesses continued to grow in West Columbus and attract consumers, it was important to update the roads and catch up with other parts of the city. (Both, courtesy of the Southwest Public Libraries.)

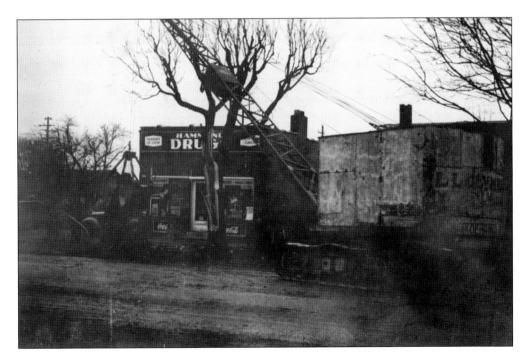

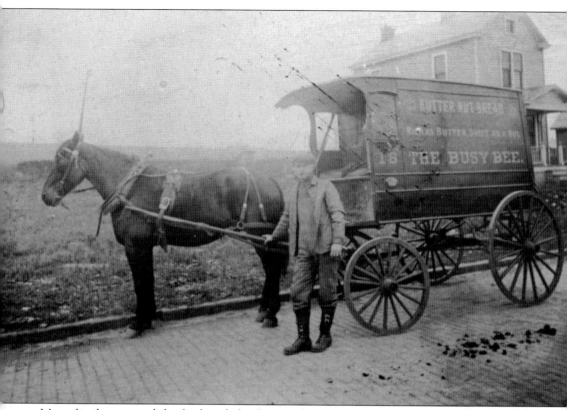

Many families enjoyed the food made by the popular restaurant Busy Bees, which had multiple locations throughout Columbus along High Street and Long Street between 1893 and 1922. Its menu featured home-cooked dishes, butternut bread, and a variety of candy. Residents enjoyed the affordable prices compared to alternative restaurants. Customers could order sliced peaches in cream or spring vegetable salad for 10¢, fresh peach ice cream for 15¢, or even a steak for the modest price of 50¢. If cravings set in, but a family could not make the trip downtown, the Busy Bee wagon, seen above, could make a home delivery. The Busy Bee deliveryman is pulling his wagon along Sullivant Avenue, near West Park Avenue in the Franklinton neighborhood in the early 1900s. (Courtesy of the Columbus Metropolitan Library.)

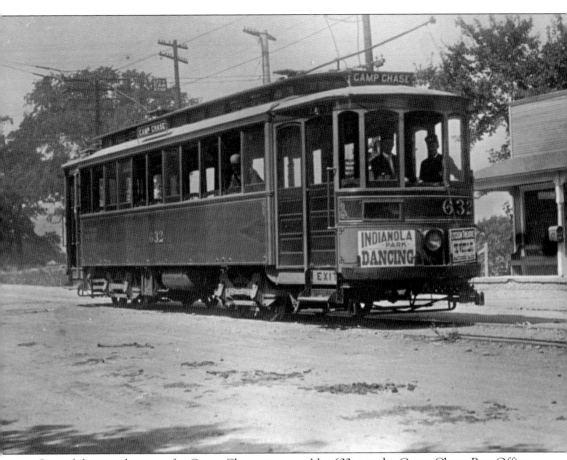

One of the popular stops for Camp Chase streetcar No. 632 was the Camp Chase Post Office, located in the 2800 block of West Broad Street, just west of Hague Avenue. Columbus was growing rapidly by the 1890s, so the Glenwood & Green Lawn Railroad Company created a streetcar system from High Street to the Columbus State Hospital. In 1891, the company adapted to electric motors, and the system was expanded farther west and into the Hilltop. The Camp Chase streetcar route entered the Hilltop via Water Street, Town Street, and Sullivant Avenue. It would then travel up Hague Avenue to West Broad Street and west toward the Big Four railroad tracks before turning around. In result of the introduction of trolley coach and motor bus service, streetcars faded out by the late 1940s. (Courtesy of the Columbus Metropolitan Library.)

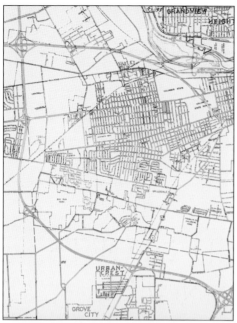

This 1920s neighborhood map of the Hilltop shows the effects of realty investments in the area. The near center of the map illustrates how much home density increased between Demorest Road and Harrisburg Pike due to neighborhood development. Just two or three decades earlier, the land would have appeared more open, like what is seen west of Demorest Road, south of Briggs Road, and to the Valleyview area north. (Courtesy of Bea Murphy.)

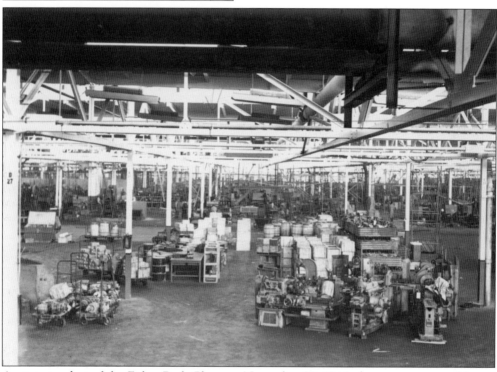

An interior shot of the Fisher Body Plant on November 20, 1946, shows car parts and heavy machinery. The company created its Columbus location following World War II due to a high demand for automobiles and their parts. The Fisher Body Plant was a huge employer when it arrived in 1946; therefore, it devastated the West Columbus economy when the company dissolved in 1984, leaving thousands without work. (Courtesy of the *Columbus Citizen*/Scripps-Howard Newspapers/Grandview Heights Public Library/Photohio.org.)

Six

BUSINESS AND SPORTS
MOVING INTO A NEW ERA

Residential growth was exponentially rising thanks to the streetcar system, and the growing number of subdivisions continued to build homes for new families to move into West Columbus. There was an estimated 2,000 people living on the Hilltop, alone by the 19th century.

So, it should be of no little surprise some of the earliest businesses were grocery stores and animal feed markets in the early 1800s. Samuel Six was one of the first businessmen to capitalize on the growing population. He ran his business, starting in 1893, for 45 years. Six catered to the local schoolchildren at lunchtime and exchanged his barter farm goods for canned goods with the locals.

The majority of businesses opened on West Broad Street, between Wheatland and Terrace Avenues. As infrastructure continued to expand, so did the population. In 1920, the population reached nearly 15,000, and the sheer number of residents could support more businesses. New businesses emerged, like the West Side Lumber Company, the Hilltop Building and Loan Company, along with a slew of pharmacies, hardware stores, and restaurants.

The Hilltop Business Association was created to better curate the commerce and build community support around thriving businesses. Events like the Hilltop Bean Dinner were created to help create a sense of closeness between businesses and the consumer.

Baseball also became a community pastime. In 1931, the St. Louis Cardinals built Red Bird Stadium on farmland on West Mound Street and Glenwood Avenue, using the same model as the Red Wing Stadium in Rochester, New York. They hired architect Howard Dwight Smith, the same man who designed West High School for the project.

The farm team became one of the favorite baseball franchises in minor league history, with record-breaking crowds of 21,000 fans—the stadium held a capacity of about 17,500. The Red Birds performed as a Triple-A team from 1946 to 1954, before the club relocated to Omaha, Nebraska.

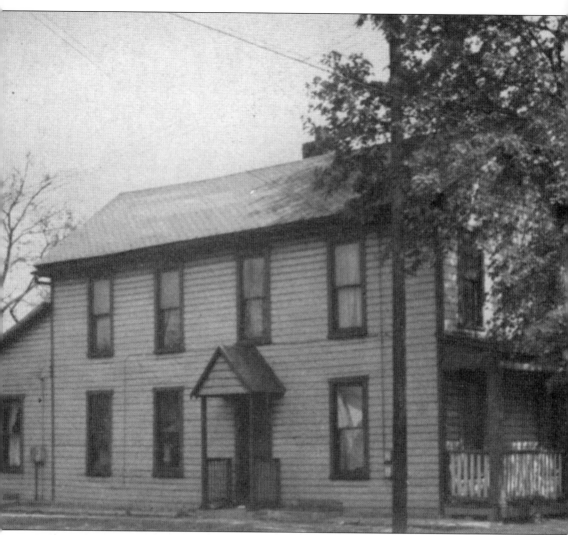

Early settler David Deardurff built the first post office in Franklinton sometime in 1807, which was located at 72 South Gift Street. It continued to be used until discontinued on October 20, 1834. The building still stands today as a historic property, officially registered in September 2001. Deardurff originally arrived at Franklinton on a trading expedition with his eldest son, David. They brought in their wagon items like axes, nails, spikes, knives, scissors, and other useful tools. They traded with the Native Americans for venison, bearskins, wild honey, and other items of that nature. After staying a few weeks, he decided he liked the community and went to retrieve the rest of his family. The Deardurffs settled in Franklinton until 1889, when they relocated to Urbana in Union County. (Courtesy of the Columbus Metropolitan Library.)

As horse-pulled wagons made their journey down the dirt road on US Route 40, the sight of Daniel McFarlands Tavern Stand on the National Road would be cause to rejoice. It became home to the Yeager family in the 1930s–1940s until it was torn down to make room for medical office space building. (Courtesy of the Southwest Public Libraries.)

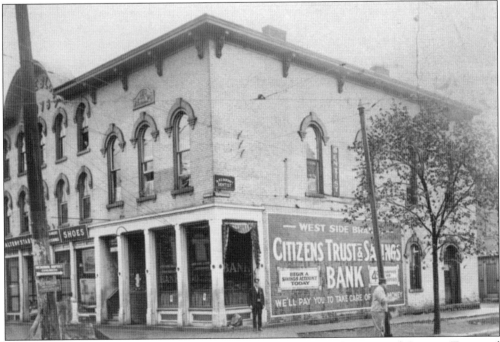

The Poole Building in Franklinton housed the West Side Dime Savings and Citizens Trust and Savings Bank. It was constructed in 1876, making it one of the older buildings in the area made from masonry. The facility, which was located at 669 West Broad Street, was demolished on July 3, 1927. (Courtesy of the Columbus Metropolitan Library.)

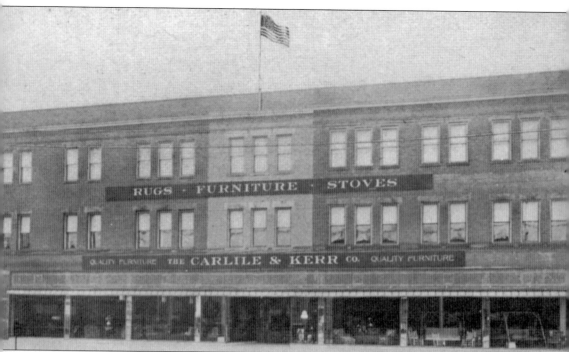

The Carlisle & Kerr Furniture Co. was established on West Broad Street in 1895, and within 24 years, it possessed the largest window display in Central Ohio. Business leaders thought the company would fail when B.F. Kerr first founded the store, but he proved speculators wrong as the store expanded every year. The reason for the doubt when the store first opened was because the Hilltop was such a small community at that point. However, the populations grew with the realty investments and subdivisions. Everyone wanted a home, and it had to be furnished. Much of its success was thanks to Kerr's son R. Stanley, who joined the family business after serving overseas during World War I. (Courtesy of the West High School Alumni Association.)

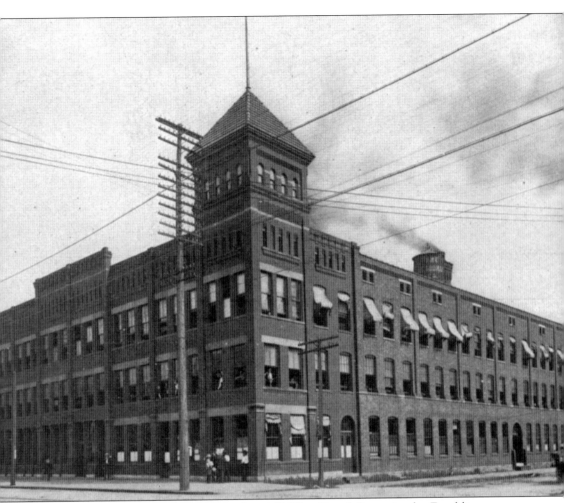

The Godman Shoe Factory was located at 347 West Broad Street in the Franklinton area. It originally opened as Hodder Godman Co. in 1874 and manufactured boots and shoes, an important commodity for a community heavily involved working on railroads and in factories. The introduction of the Ohio Canal and the National Road helped the population explode. Godman was located in the factory district, which was positioned along the Scioto River. It had become an industrial city by the 20th century, and businesses like Godman needed workers for growing demands. Around 1912, the Godman Shoe Factory was one of the earliest employers to hire women. There was a good amount of scrutiny that factories did not create the best working conditions for women because they were not provided dressing rooms or places to eat and were given low wages. However, Godman was commended by women advocates as one of the few model workplaces for ladies in the city. (Courtesy of the Columbus Metropolitan Library.)

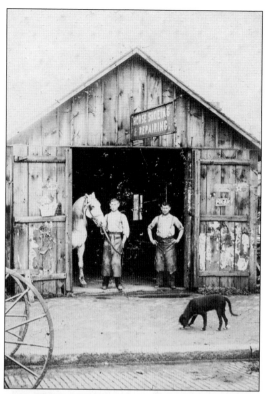

The Sheridan Brothers Blacksmith Shop operated from a barn at 406 West State Street in the Franklinton area. This is an example of how much business evolved since the late 18th century. The Sheridan brothers are pictured outside their workshop. The family-owned business specialized in the repairing of horseshoes and other blacksmithing needs. (Courtesy of the Columbus Metropolitan Library.)

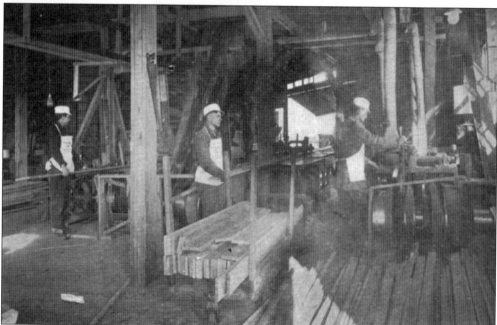

Pictured above are employees at the Central Avenue Lumber and Supply Company, which operated in the Hilltop area between 1912 and 1918. The following year, it was taken over by the Matthews Lumber Company. The business specialized in lumber, doors, sash, and millwork and was located at 500 South Central Avenue. (Courtesy of the Columbus Metropolitan Library.)

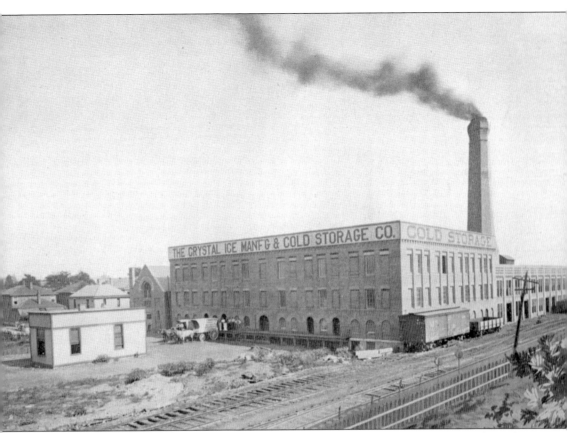

One of the manufacturing plants in West Columbus to undergo multiple changes throughout the years is the Crystal Ice Manufacturing and Cold Storage Company. The building was constructed in 1891, and at the time, it was the largest facility of its type. It was also state of the art and was located at 397 West Broad Street. The building changed hands a number of times over the years; it became City Ice and Fuel in 1923 and then City Products Corporation in 1953. Spaghetti Warehouse then purchased the facility and opened on April 20, 1978. The building had to undergo major renovations in order to function as a restaurant, including the addition of a San Francisco trolley car placed inside, as is traditional for the franchise. The restaurant also now features rare stained-glass windows and other antiques to create a nostalgic atmosphere. (Courtesy of the Columbus Metropolitan Library.)

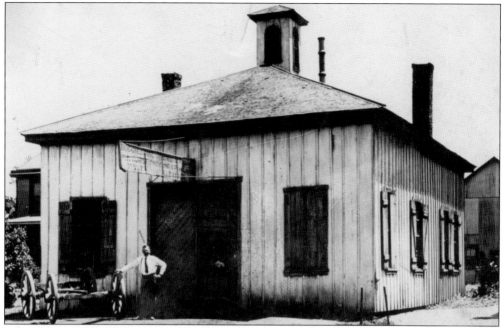

One of Rome area's landmarks is John Althen's blacksmith shop on West Broad Street and Norton Road. The shop operated through the 1930s and repaired buggies, surreys, and other conveyances that needed fixed or new tires. Althen also repaired shoes on horses and oxen at the location. (Courtesy of the Southwest Public Libraries.)

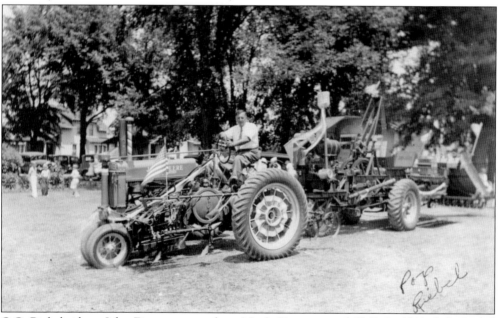

O.G. Riebel rides a John Deere tractor along Maple Drive around 1940. In 1919, O.G. Riebel opened a general store at the corner of Maple Drive and West Broad Street in the far west. The first floor housed the store, and the second floor was where the 10-member family lived and an overalls factory operated. Riebel was elected the first mayor when the community was incorporated as the now defunct New Rome in 1941. (Courtesy of the Southwest Public Library.)

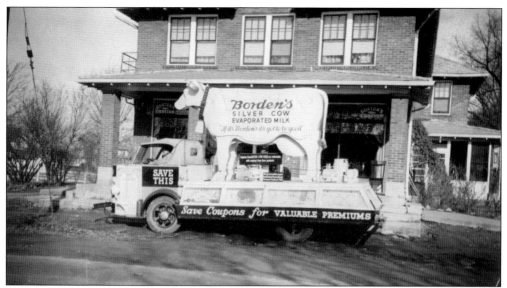

Parked outside the Riebel's family-owned business is a Borden's Silver Cow advertising truck. The business was one of the last landmark stores in the far west community, located at 5290 West Broad Street. It was sold to Russ Harrison in 1944 and eventually demolished about 50 years later. (Courtesy of the Southwest Public Libraries.)

When O.G. Riebel decided to sell his business, one of the biggest selling points was its proximity to the development of the automotive plant. He listed his home and business for $30,000 during the 1940s. When Riebel became mayor of the New Rome development, he actually enclosed the porch of this building, and it became the official mayor's office. (Courtesy of the Southwest Public Libraries.)

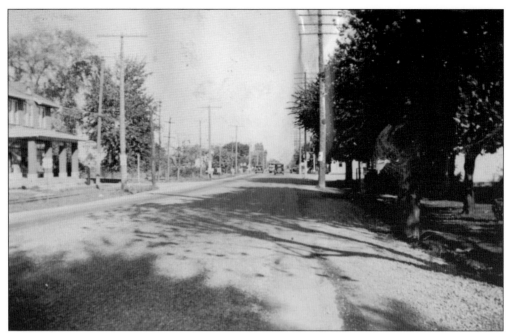

Pictured above are interurban tracks running down West Broad Street in the 1930s; the Riebel's Grocery can be seen on the far left of the image. When the tracks were first laid, the road was not yet paved. Broad Street was a two-lane gravel road during this time. (Courtesy of the Southwest Public Libraries.)

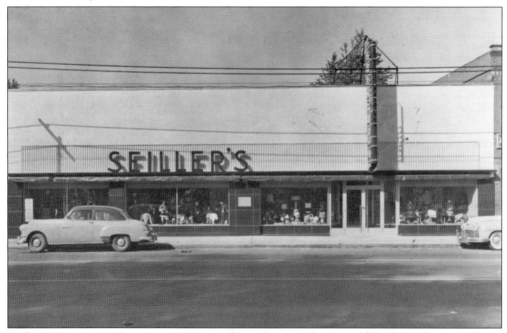

Seiller's Department Store was a one-stop shop where residents could find just about anything. It opened its doors also around 1909 on West Broad Street and quickly grew from a small dry goods store to a department store that attracted shoppers from all over the city due to its reputable customer service. (Courtesy of the Greater Hilltop Community Development Corp.)

Heavy snow covers the Riebel farmstead and grocery store in the Rome area during the winter of 1936. The region of West Columbus accumulates an average of 26 inches of snowfall each year. Residents are conditioned to withstand the unpredictable weather. The city saw its greatest snowfall in 1880, with about 62 inches of snow that year, and in 1909, with about 68 inches of snow. The area's first blizzard was in January 1918 when nearly seven feet of snow fell statewide, with winds of 50 miles per hour. (Both, courtesy of Nola Freeman.)

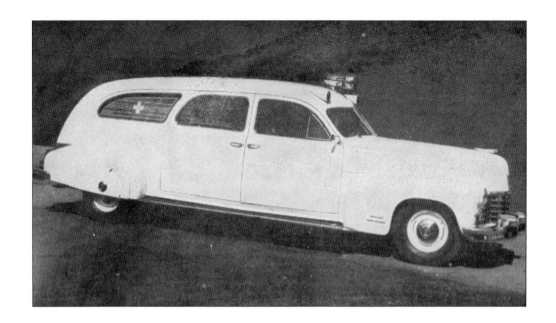

There were a number of competing family-owned funeral homes in West Columbus, which sprouted up during the first half the 20th century. To expand their businesses, some family operations like the Shroyer Funeral Home began to offer ambulance services. Pictured above is one of the first ambulance vehicles they utilized in 1931. The family was able to add a second location on West Broad Street and newer hearses and ambulances by 1948, as pictured below. (Both, courtesy of the West High School Alumni Association.)

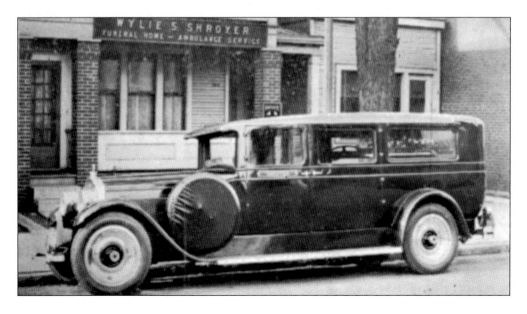

William Gearhart owned a confectionery store until he decided that opening a hardware store would be a better business investment. In September 1929, he opened the first location of Gearhart's True Value Hardware Store at 2387 Sullivant Avenue in the Hilltop neighborhood. Gearhart added onto the building in 1936. The store would relocate to the former Rite-Aid at 2885 West Broad Street in 2003. (Courtesy of David Miller.)

After Gearhart died in 1946, the business was taken over by his nephew Jack Boyer. The hardware store stayed within the family when Boyer passed along the business to his nephew David Miller in 1989. Many residents were saddened when the iconic Gearhart's sign from the original store could not be zoned to follow the family to its new location. (Courtesy of David Miller.)

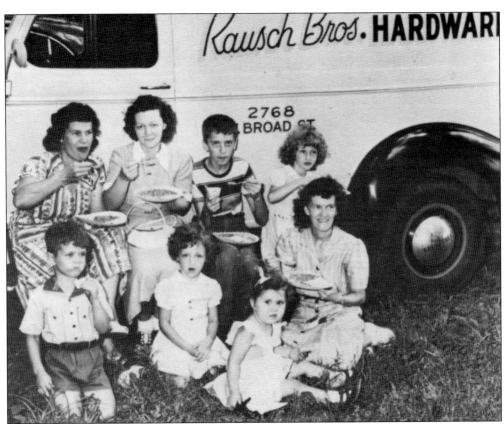

Since the 1930s, the Hilltop Business Association has hosted annual bean dinners at Westgate Park to show appreciation to the community. It is common for organizers to go through 50 cases of beans, 20 cases of cornbread, and 2,000 hotdogs within a day. This type of event was made popular by veterans during the Civil War. (Courtesy of Greater Hilltop Community Development Corp.)

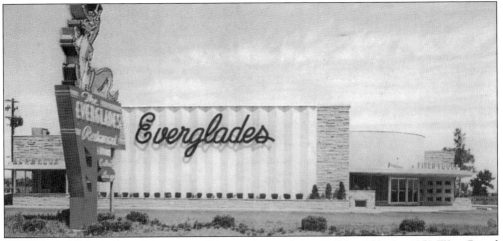

The Everglades Italian and American Restaurant opened up in the 1950s at 4250 West Broad Street. It operated as a premiere cocktail lounge and social hot spot for a little over a decade until it closed and was replaced with an H.H. Gregg electronics store. It represented a time when West Columbus's economy was moving forward. (Courtesy of Nola Freeman.)

Going to one's neighborhood beauty salon was a weekly ritual for many housewives in West Columbus by the 1950s, as pictured right. The regular encounters built strong relationships between the customers and hairdressers. It was even common for hairdressers to style their clients hair after they passed away for their funeral viewing. A popular beauty spot in the Westgate neighborhood was Westmoor Beauty Salon, which was known for its fun and extravagant window displays the ladies rotated throughout the seasons, pictured below. (Both, courtesy of Connie Kaufman.)

The Old Trail Inn served as a fixture for the far West Columbus community since it opened in 1947. The restaurant and bar, located at 72 South Grener Road, was known for its vast collection of antiques and other items on display on its walls. Items ranged from signage from local breweries and vintage maps of the city to curiosities like a 100-year-old stuffed bald eagle. There were also paintings of Annie Oakley and Buffalo Bill, as seen below. The popular watering hole closed in 2012, a few years following the death of its original owner, Val Bohem. (Both, courtesy of the Columbus Messenger Newspapers.)

Ohio governor James Cox sits to the right of New York governor Franklin D. Roosevelt during a Red Birds game on August 20, 1932. Roosevelt spoke in a live broadcast during the game as part of his Democratic campaign tour. Below, Major League Baseball commissioner Kenesaw Mountain Landis is seen during the season opening at Red Birds Stadium in June 1932. Landis was a former federal judge, appointed by Pres. Theodore Roosevelt in 1905, and later, he became the first commissioner of baseball from 1921 until his death in 1944. (Both, courtesy of the Columbus Metropolitan Library.)

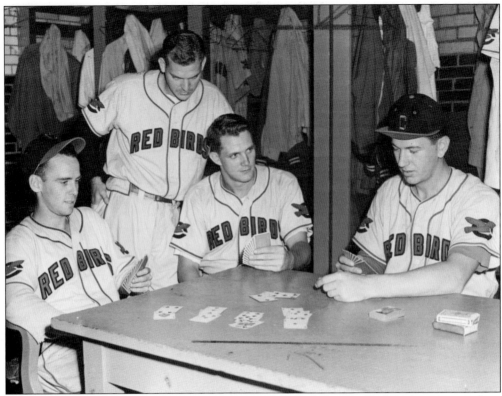

During a little downtime in the summer season of 1949, Columbus Red Birds team members (seated at the table, from left to right) John Remke, Ellis Melvin McGaha, and Kurt Krieger play a casual game of cards in the locker room. Fellow team member Ellis Deal watches from behind. (Courtesy of the *Columbus Citizen*/Scripps-Howard Newspapers/Grandview Heights Public Library/Photohio.org.)

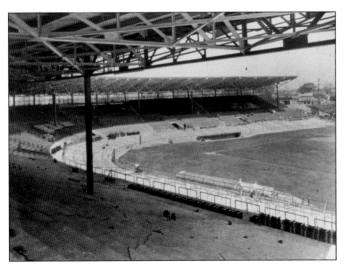

Between the years 1955 to 1970, the baseball stadium at 1155 West Mound Street was the home to the Columbus Jets. It was renamed from the Red Birds Stadium to Jet Stadium, when the Ottawa Athletics relocated from Ottawa, Canada, when businessman Frederick E. Jones purchased the team for $110,000. In 1971, the team would relocate again, this time to Charleston, West Virginia. (Courtesy of the Columbus Metropolitan Library.)

On July 16, 1886, Hawkes Hospital of Mount Carmel, present-day Mount Carmel West Hospital in Franklinton, was dedicated. Two men were pivotal in the foundation. The first was Dr. W.B. Hawkes who donated the initial money to build the facility in 1885. Dr. John Hamilton picked up the project, following the death of Hawkes, and then helped convince the Sisters of the Holy Cross in Notre Dame, Indiana, to staff the hospital. The hospital was a four-story redbrick building with two wards, one operating room, eighteen patient rooms, and an amphitheater. More than a decade later, the hospital expanded its campus to include the Mount Carmel School of Nursing in 1903. The Congregation of the Sisters of the Holy Cross founded it. (Courtesy of the Columbus Metropolitan Library.)

In the 1940s, neighborhood men and their sons visited Ezzo's Barbershop at 41 North Harris Avenue near the Highland West subdivision on the Hilltop. World War II veteran John Ezzo owned and operated the shop, located next to the local post office, for 34 years before he retired. The family owned a number of other businesses on the Hilltop, from pharmacies to food spots. (Courtesy of the West High School Alumni Association.)

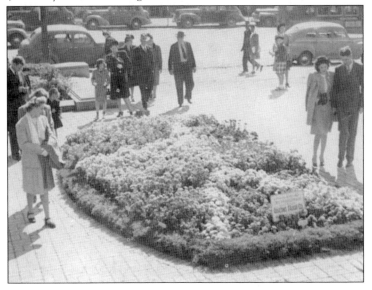

Pictured are visitors at the annual Columbus Flower Show in the spring of 1948. Students at West High School participated in this event each year, showing off the horticultural skills they learned at school. Their display, seen here, featured 17 varieties of flowers. (Courtesy of the West High School Alumni Association.)

The Columbus Plastic Products building shortly after it completed construction in 1946. The general contractor and builder was George Sheaf. The factory, located at 1625 West Mound Street, operated until 1966, when the United Way occupied it in 1985, followed by the Mid-Ohio Food Bank in 1995. (Courtesy of the Columbus Metropolitan Library.)

Residents Norman Davis and Jack Boyer work on the engine of one of their go-karts. The blue law of the 1940s prohibited a wide majority of businesses from operating on Sundays. Men enjoyed using their day off from work to tinker with their go-karts. (Courtesy of David Miller.)

J. Curtis Allen was the official photographer for many of the schools, churches, and organizations on the Hilltop during the late 1940s. He had a studio on the 2300 block of West Broad Street, which is now demolished. Here, Curtis takes a picture of West High School student Doris Thomas. (Courtesy of the West High School Alumni Association.)

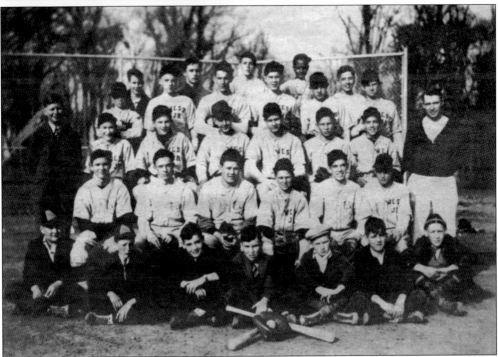

Pictured above is the 1937 seventh-grade baseball team at West High School. The coach that year was George Williams. Baseball was becoming a widely popular sport in the area, with the Columbus Red Birds having popped onto the scene just a few years prior in 1932. It would be hard to find a baseball diamond around the Hilltop neighborhood that was not being utilized during this time. (Courtesy of Dan Gatwood.)

Seven

EDUCATION
FROM A LOG CABIN TO
LARGEST DISTRICT IN OHIO

In 1806, Lucas Sullivant erected a log building just north of West Broad Street at Washington Street and present-day Sandusky Street to serve as the first school in Franklinton. It was not the most pleasant environment for learning; it was infested with fleas and hogs underneath the floorboards.

Since school was not mandatory until after the Civil War, many of the early schools in West Columbus were log structures privately owned and operated. A number of private schools opened in the 1820s but were fleeting entities.

Five years after Ohio Legislature authorized public school systems, Franklinton created its own school district in 1826. Although not yet annexed into Columbus, it merged with Columbus schools in 1838 and became the Columbus Public School District. Today, it is the largest district in Ohio.

The City of Columbus had an aggressive stance on annexation. This meant that the Columbus Public School District acquired a number of former school buildings that were rehabbed, adapted, or razed for its expanding enrollment needs. Between the years 1889 and 1916, the district grew from 13,500 students to 28,590.

The growth resulted in the district's first building campaign and the erection of West High School. Students from West Columbus finally had a neighborhood school rather than having to travel to the centralized location at Central High School.

This time period also gave way to new elementary buildings in West Columbus that included Avondale, Highland, and Chicago schools. These buildings were characterized by their prominent, three-story masonry design and punctuated with central towers and constructed from a mix of materials.

The baby boom after World War I resulted in the need for additional buildings. From this initiative, the district built a new West High School and John Burroughs Elementary School. In the 1920s, the district wanted to build neighborhood-based schools instead of a centralized model.

During World War II, there was little to no construction in the country, and schools faced overpopulation. In 1945, residents passed 13 levies and bond issues, which allowed new neighborhood schools to be built in West Columbus; this included West Mound, Westmoor Junior High, Wedgewood, Georgian Heights, and others.

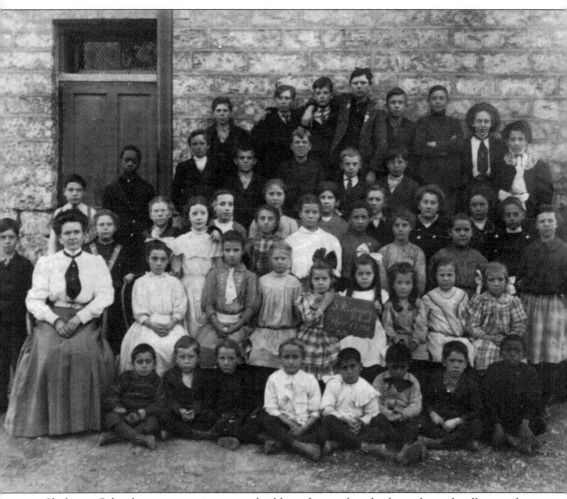

Skidmore School was a two-story stone building that replaced a log cabin schoolhouse along Hague Avenue, as seen in this 1908 elementary class photograph. The school was constructed around 1866. In the center of both of the two classrooms were potbellied stoves. First- through fourth-grade students were instructed on the ground floor. The older kids had to climb a stairway from the building's south side to attend classes on the second story. Stories exist on how kids would use seeds from the hackberry tree in the schoolyard as ammunition; they would jam a hollow pencil with the seeds and then flick them at each other, using the pencil as a makeshift slingshot. The school was abandoned in 1910 when the district planned to acquire and rename it Hague Avenue Elementary School, but those plans failed. In 1920, it was instead acquired by South-Western City Schools and named North Franklin Middle School. (Courtesy of the Columbus Metropolitan Library.)

In 1873, Fieser Elementary School was built at 335 State Street at the corner of Starling Street. Local residents nicknamed the school "Fieser College," and it was meant to initially serve kids in the Bottoms. The school grew quickly to 480 pupils, so a four-room addition was made to the building in 1875. The building had 12 classrooms, which were heated by steam. This was ahead of the curve, since many schools used fireplaces or open flames to keep warm during the winter. In April 1911, there was a push in the public eye to pay more attention to the health of children. This resulted in the school being converted into an open-air teaching model for children with tuberculosis. About a decade later, the school was abandoned on December 5, 1922. (Courtesy of the Columbus Metropolitan Library.)

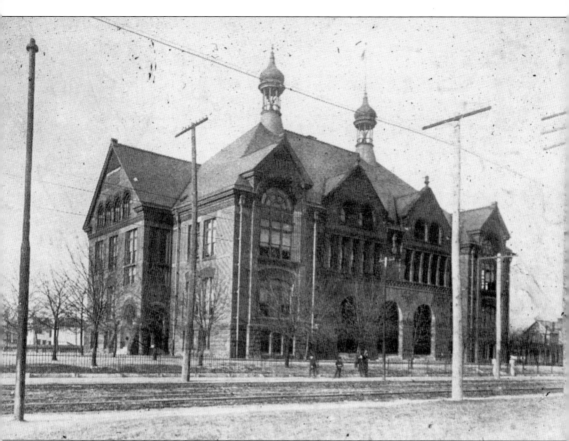

Avondale Elementary School was built at 156 Avondale Avenue, at the corner of Town Street in Franklinton. The school was designed by David Riebel in 1892 and erected within a year. This was one year prior to Riebel being named the district's first full-time school architect in 1893. Avondale opened with 295 students and employed 16 full-time teachers. Its enrollment doubled to 587 pupils by 1916 under the leadership of principal Lucy Thompson. The school was purposely designed to be focal point of the neighborhood, with its towering presence over neighboring homes and buildings. Riebel looked toward Gothic cathedrals as a model when planning the structure, from its architectural features to mixed building materials. Avondale, along with other schools he designed in the 1890s, are considered some of the city's most treasured architectural landmarks. (Courtesy of the Columbus Metropolitan Library.)

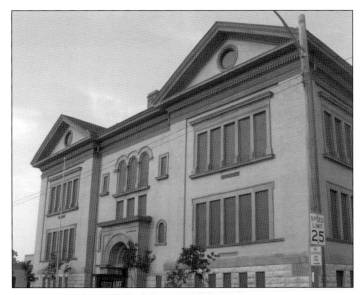

The Chicago Avenue School opened its doors in September 1898, located at 40 North Chicago Avenue in the Franklinton area. The building grew to house 430 students, and school employed 12 teachers by 1916. The principal for many years was Ada Stephens. The school closed in 1982, and the building is now home to the Youth for Christ City Life Center. (Photograph by Aaron Turner/Oldohioschools.com.)

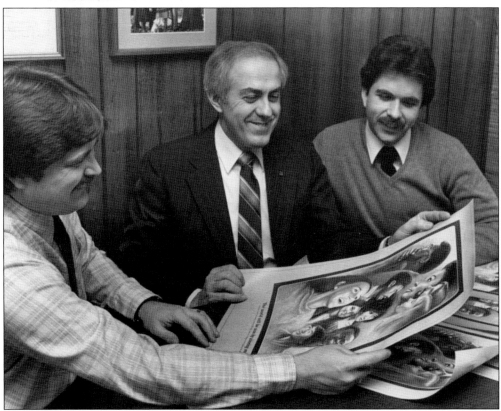

Art Deyo, director of the Columbus area Youth for Christ Center, looks over materials with colleagues Gary Raad and Harvey Hook. This organization procured the former Chicago Elementary School in the 1980s to expand its services, which aim at engaging youth to make better life choices. (Courtesy of the *Columbus Citizen-Journal*/Scripps-Howard Newspapers/Grandview Heights Public Library/Photohio.org.)

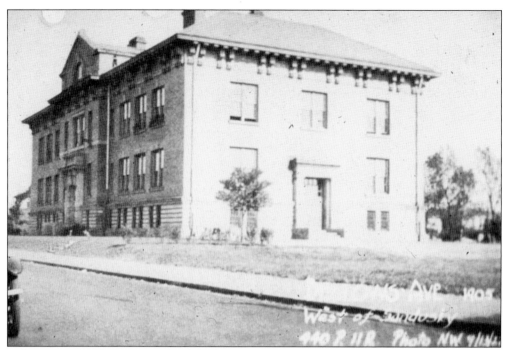

Bellows Avenue Elementary School, built in 1905, was located at Sandusky Street and Bellows Avenue in the Franklinton neighborhood. The school first opened with 350 students, 13 classrooms, and 11 teachers and cost the district $45,200 to construct. Students who lived between Town Street and Greenlawn Avenue attended the school. The school and street were named in honor of architect George Bellows Sr. Pictured below is Bellows Avenue Elementary School today; it was closed and abandoned in 1977. The Columbus Landmark Foundation placed the school in the top 13 endangered historic buildings in Columbus. (Above, courtesy of the Columbus Metropolitan Library; below, photograph by Aaron Turner/Oldohioschools.com.)

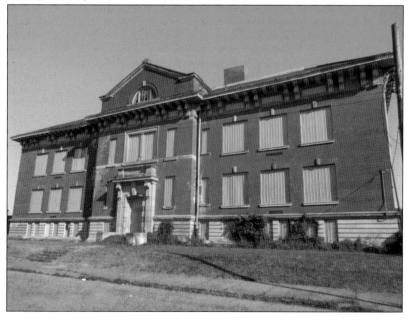

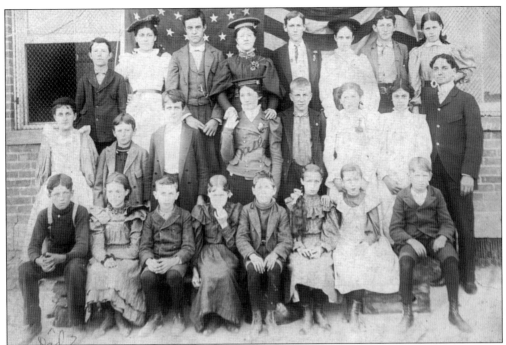

Pictured above are students in attendance at the long-gone Briggsdale Elementary School in 1910, about one year after it was built along Harrisburg Pike, located roughly between present-day Clime Road and Briggs Road. Pictured below, first-grade teacher Mary Wolf teachers her students, including Mary Campbell, Margaret Rider, Harry Maxwell, and Jack Seese in March 1929. The school was locally referred to as Briggsdale Academy and has since been demolished. This building replaced an earlier Briggs School, built a little over a decade earlier thanks to the efforts of Joseph Briggs, who was a strong advocate for education. (Both, courtesy of the Southwest Public Libraries.)

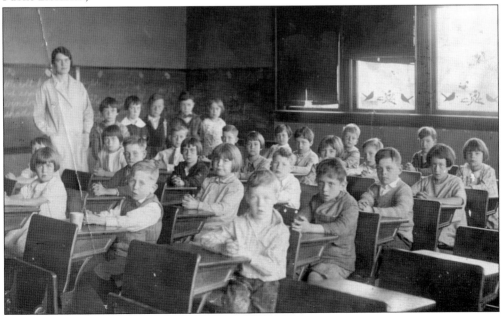

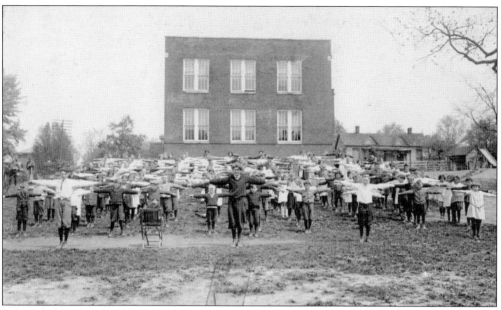

Pictured above are first- and second-grade students outside the Galloway School during physical education class around the mid-1920s. In the photograph below, a class of first-grade students poses outside in 1923. The school, built in 1916, was located at 2010 Galloway Road and named in homage to Samuel Galloway, a politician who served as the judge advocate of Camp Chase during the Civil War, appointed to the role by Pres. Abraham Lincoln. Galloway died while living in Columbus on April 5, 1872, and was interred in Green Lawn Cemetery. (Both, courtesy of the Southwest Public Libraries.)

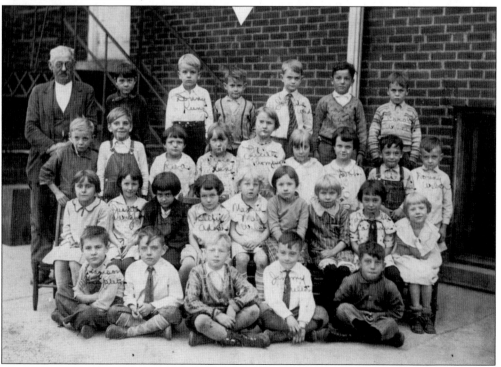

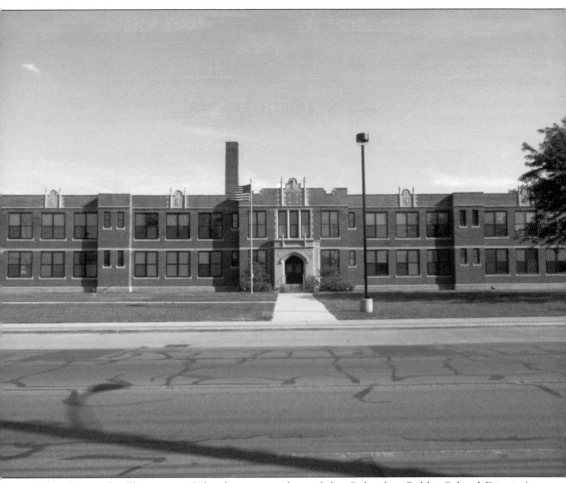

John Burroughs Elementary School was a product of the Columbus Public School District's building campaign following the World War I. It finished construction and opened on September 5, 1921. The $417,129 building still functions today at the location of 2585 Sullivant Avenue in the Hilltop area. John Burroughs Elementary School is characterized for its long orientation, as it sits on a little over seven acres of land. The playground itself takes up approximately 6 acres. The building was also designed with a combination gymnasium and an auditorium. In 1928, the enrollment required district officials to add 12 new classrooms to the building, for a total of 31 classrooms as a whole. This building was designed during Howard Dwight Smith's tenure as district architect. The school district fully restored the facility in 2007, and it still houses students today. (Photograph by Aaron Turner/Oldohioschools.com.)

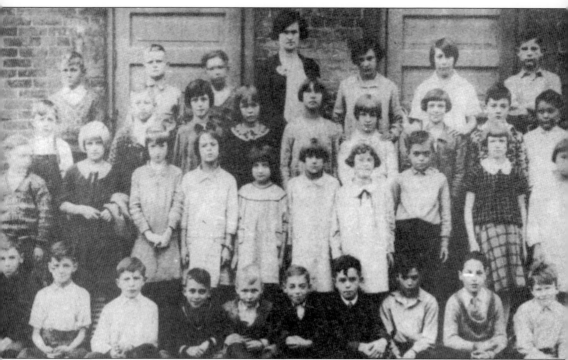

Pictured above are children from Harrisburg Elementary School in 1927, which includes children from a number of families who were the first to purchase land in West Columbus like the Harris, Alkire, Van Horn, and Dyer families. In the early 1900s, when real estate investors came in and began purchasing farmland to transform into subdivisions, some of the original families took the opportunity to relocate their farms. This class photograph illustrates how some families moved south, while others moved out of Franklin County, like the Clime family and the Deardurff family, or moved clear out of Ohio, like the Briggs family. (Courtesy of the Southwest Public Libraries.)

Although Rome School was for primary grades, many of their theater productions were advanced for kids that age. Some of the operettas the teachers chose to produce are more commonly aimed toward high school drama classes. Pictured above is the cast of Rome School's production of *It Happened in Holland* in April 1941. Similarly, pictured below are kids who participated in a performance of *Windmills of Holland* in March 1935. Both of these plays were vastly popular between 1910 and 1950 and performed by most theater classes across the country. (Both, courtesy of the Southwest Public Libraries.)

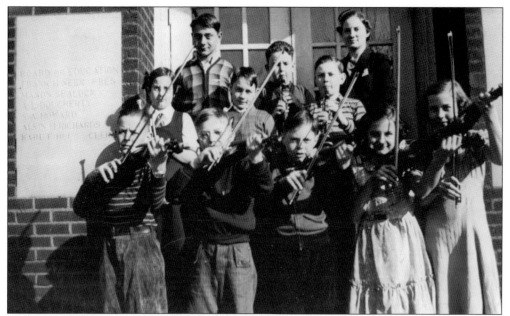

Pictured above are sixth-grade students at Rome Elementary School on March 2, 1939. The students learned to use string instruments and participated in the school's spring production of *Snow White* as members of the orchestra. Each spring, the school produced an operetta. (Courtesy of the Southwest Public Libraries.)

On the left is an example of how report cards looked for students in the 1940s; the one viewed on the left was brought home by Elma Lou Riebel during her eighth-grade year in 1941. During this time, the now defunct Franklin County Public Schools District operated the schools in the Rome area. The district would be absorbed into the South-Western City Schools District during a merger of various small districts in 1956. (Courtesy of the Southwest Public Libraries.)

This was the playbill belonging to Elma Riebel when she participated in a production of *Snow White* at Rome School in March 1939. Elma played the lead role of Snow White, along with 20 other classmates who performed in the production. (Courtesy of the Southwest Public Libraries.)

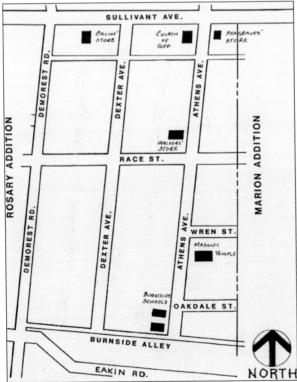

The majority of students at Burnside Heights School lived in the neighborhood of Burnside Heights, which consisted of three streets between Eakin Road and Sullivant Avenue (formerly New County Road). The streets included Demorest Road, Dexter Avenue, and Athens Avenue. (Courtesy of Bea Murphy.)

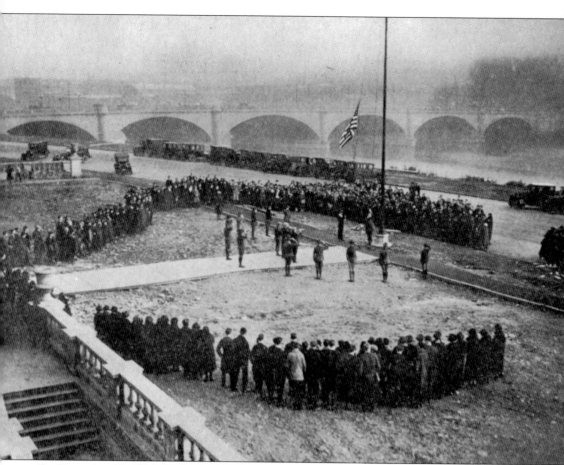

On December 12, 1924, the first public flag-raising ceremony took place at Central High School. There were about 1,700 students present at the inaugural event, the large number a result of the school being the central location for all Columbus Public School District high school students. They were led in the Pledge of Allegiance by principal W.M. Townsend. In 1862, Central High School's first building was built at 303 East Broad Street and was the first in all of Columbus to be devoted entirely to high school students. During this era in public schools, officials thought a centralized location was easier for residents. However, the commute for families in West Columbus was a burden. It relocated closer to Franklinton in 1924, but by this time, many teenagers were attending West High School. (Courtesy of the Columbus Metropolitan Library.)

Pictured above, students J. Long (left) and B. Fox work in the machine shop during occupational activities at Central High School. Seen below, the varsity majorettes strike a pose on the football field. The high school's second location at 75 South Washington Boulevard, on the outskirts of Franklinton, eventually closed in 1982. The site was partially conserved almost two decades later, when the COSI (Center of Science and Industry) acquired the property to construct a state-of-the-art science center. The facade of the former high school was salvaged and used as the exterior facing its east entrance. Architect Arata Isozaki blended the 1924-era front with a futuristic look at the west entrance. (Both, courtesy of Sally Rose.)

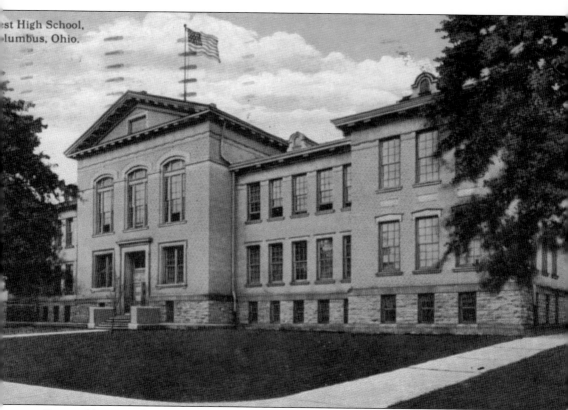

One could imagine how appreciative families in the Hilltop area were to learn that their children would be able to now walk to school; following Columbus Public School's announcement, it built a high school in the area. West High School's original building opened on September 18, 1908, on South Powell Avenue. This structure was later converted into Starling Junior High School on January 28, 1929. The school district invested $943,953 the year prior to begin construction on a new building to hold West High School, located farther down the road on South Powell Avenue. The changes were part of the school district's $10 million building campaign that started in 1920. The new high school was also designed by Howard Dwight Smith, the architect behind The Ohio State University's Football Stadium and the Red Birds Stadium. (Courtesy of Hope Moore.)

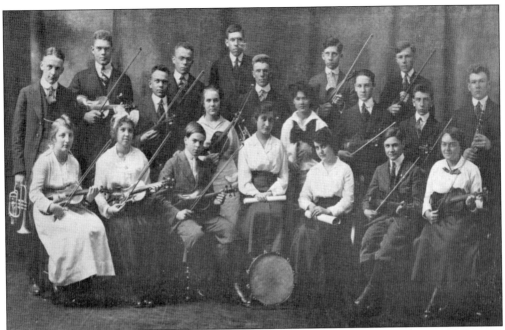

Pictured above are members of the West High School Orchestra in 1916; and pictured below are members of the junior class of 1915. These photographs were taken prior to the construction of the high school's second building, but more importantly, these images offer a fun look at how much has changed in style over the last 100 years, when kids decide what to wear for their school pictures. All the girls wore dresses and flower hats, and boys all wore ties, with the choice between derby caps, bowler hats, and top hats. (Both, courtesy of the West High School Alumni Association.)

Pictured above, West High School students, from left to right, Bill Barnes, John Jester, Bill Snashell, and Mendel Webb perform an electrical experiment in their twelfth-grade physics class in 1942. During wartime, the high school offered classes geared toward enriching the students with skills that would be valuable in the military. The students even had practicum courses off campus, where they worked on live military jets and planes, as seen below. Many seniors would later join the Air Force following graduation, where they were able to find careers either working on aircraft or piloting the machines. (Both, courtesy of the West High School Alumni Association.)

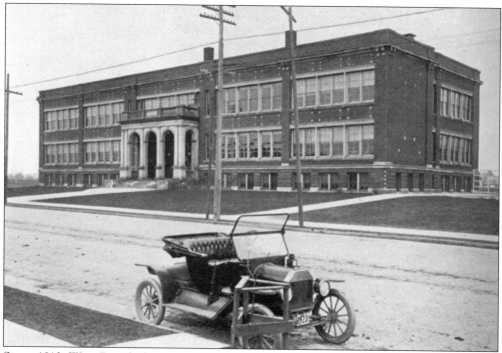

Since 1910, West Broad Elementary School has sat at the corner of West Broad Street and Hague Avenue in the Hilltop neighborhood. It was the product of rapidly growing enrollment in Columbus City Schools and became one of the four-dozen schools designed by David Riebel, who served as the school district's first full-time architect from 1893 to 1922. (Courtesy of the Columbus Metropolitan Library.)

The West High School Marching Band entertains fellow students, teachers, and parents during a halftime at Magly Field. The football stadium was built in 1937 and named after Otto H. Magly, the school's first principal, who served the students for 30 years. (Courtesy of the West High School Alumni Association.)

Student athlete Stan Ballinger warms up for daily practice by jumping hurdles during track and field at West High School in 1941. Later that year, the team placed fourth in the city track meet at The Ohio State University on May 8–9. The team then placed second at a triangular meet on May 13 in Upper Arlington. (Courtesy of the West High School Alumni Association.)

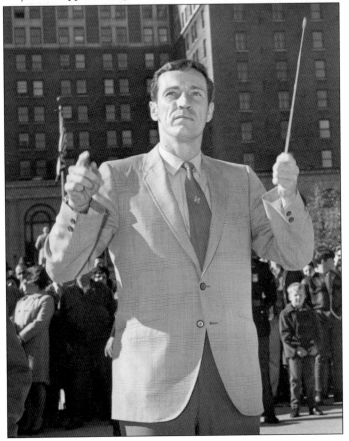

Astronaut Donn Eisele directs the West High School band on the steps of the statehouse. Eisele graduated from West High School in 1948, where he competed in track and cross-country and was an Eagle Scout. He trained for five years for his Apollo 7 mission, which launched in October 1963. (Courtesy of the *Columbus Citizen-Journal*/Scripps-Howard Newspapers/ Grandview Heights Public Library/Photohio.org.)

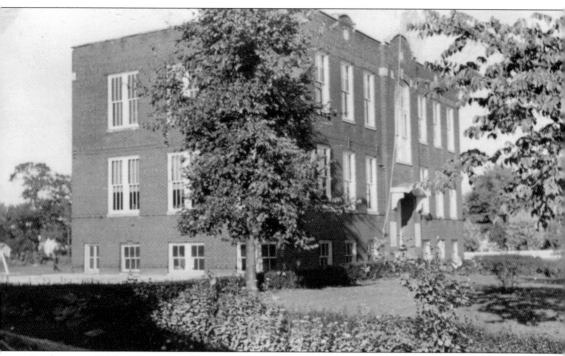

By the time 1915 swung around, many of the residents in the Rome area were exhausted by their outdated, one-room school facilities. A $42,000 bond issue was brought forward by the Franklin County Public School District. It was passed by a margin of 18 votes, which resulted in the construction of a new six-room school on Norton Road for first- through eighth-grade students. The building had no electric until teachers paid for it by going around the neighborhood and selling corn-fritters and candy. It was later demolished, and Prairie Norton School was built down the road. The school district shared the same problem many others in the state had, which was that it did not have a strong financial base. In 1956, citizens from six struggling districts began meeting, and what came out from those discussions was a merger. With combined funding, the new South-Western Local District could better afford new, updated facilities. (Courtesy of Nola Freeman.)

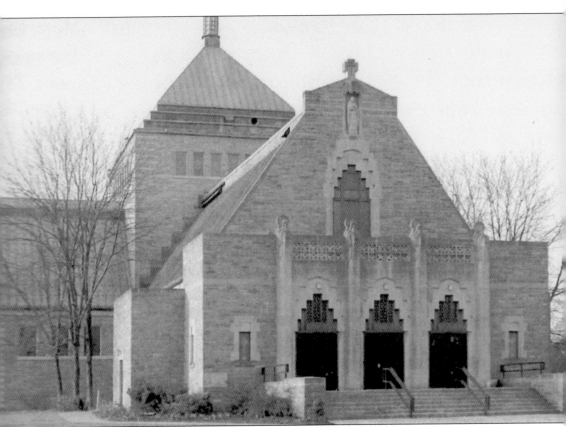

Saint Mary Magdalene Roman Catholic Church has been a cornerstone for many residents in the Westgate neighborhood. The church and its school have been a social and spiritual outlet for the community since it was first dedicated in September 1928. From the beginning until 1974, students were taught by the Franciscan Order of Sisters of Mary Immaculate, who also lived on its grounds until 1939. About 10 years later, the church continued to grow, and it expanded with the $19,000 addition of St. Raymond's Hall, which was intended to be used as a meeting space and recreation center. Instead, the parish began to house its classes in the annex. The church gained nearly 1,000 members by 1954 and had enrolled 510 students in its school. Its continued growth required more space, so a new church building was erected a few years later at the cost of $499,000. (Courtesy of the Westgate Neighbors Association.)

Eight

RELIGION
A CHURCHGOING COMMUNITY

Churches have been an important aspect of West Columbus stretching back to the early Quaker settlers. Today, there are churches on just about every block and in many denominations. Churches not only provided a gathering space for clubs and charitable organizations, but also schools.

When the Burnside Heights subdivision closed its original school building, the small school was later moved into the neighborhood church. And the opposite happed sometimes, like when Parkview United Methodist Church used West High School for some of its early services while awaiting its church's construction.

On February 8, 1806, Rev. James Hoge organized the First Presbyterian Church in the Franklinton neighborhood. Lucas Sullivant was one of the first members, along with George Skidmore, Samuel King, and Joseph Hunter.

Catholic churches appeared starting in 1877, when Holy Family was opened on West Broad Street with an Irish Mass. Four more Catholic churches would be built in West Columbus: St. Cecilia in the far west in 1882, St. Aloysius on the Hilltop in 1927, St. Mary Magdalene in the Westgate and Camp Chase neighborhoods in 1928, and St. Agnes in Franklinton in 1954.

Highland Avenue Friends Church was the very first church to appear in the Hilltop neighborhood, built in 1893. During that same year, a group of Methodists began meeting at a rented schoolhouse at present-day Clarendon Avenue, formerly known as Price Avenue. The Glenwood Methodist Church also created a Sunday school program in 1893, which had an impressive 63 children attend.

In following years, a number of other churches sprang up, including Hoge Memorial Presbyterian Church, Oakley Avenue Baptist Church, and the Hilltop Lutheran Church.

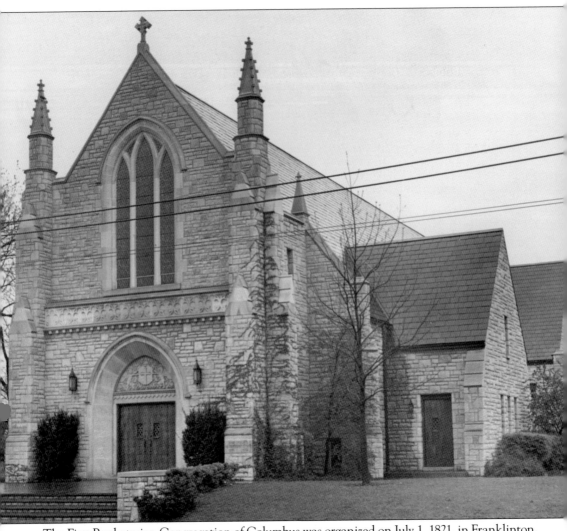

The First Presbyterian Congregation of Columbus was organized on July 1, 1821, in Franklinton. Known today as Hoge Memorial Presbyterian Church, it is located at 2930 West Broad Street. James Hoge had previously helped found the Franklinton Church, the first worship service in any denomination about 10 years prior. He first arrived in Franklinton on November 19, 1805. The first service he ever held was in the home of John Overdier, the location for early court cases as well. Most of the congregation was made up of immigrants from the East, which arrived following the Ohio Canal and National Road opening up. The First Church was successful in gaining members, as it was the only Presbyterian church available at the time it opened. In fact, there were 326 members by 1839, which meant the church was also strong financially through tithes. (Courtesy of the *Columbus Citizen-Journal*/Scripps-Howard Newspapers/Grandview Heights Public Library/Photohio.org.)

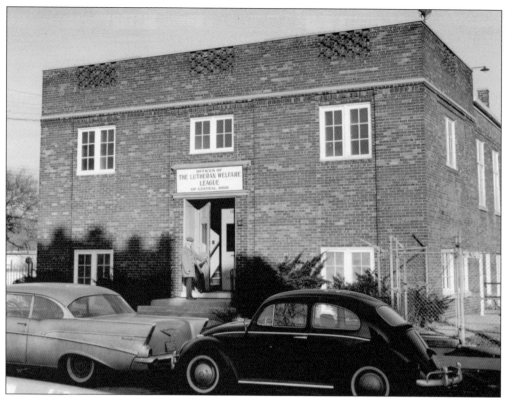

The Lutheran Welfare League, known today as Lutheran Social Services of Central Ohio, was organized in 1912 to provide general charitable and religious works for the community. It opened its first office at 104 South Gift Street in the Franklinton neighborhood. The facility was equipped with an auditorium, stage, kitchen, and basement. On Sundays, the staff organized evening worship services, and in the afternoon, the organization offered religious classes for the community. The church grew to include the following programs: food pantries, disaster response, nursing services, and other resources that assist the needy or burdened. (Both, courtesy of the Lutheran Social Services of Central Ohio.)

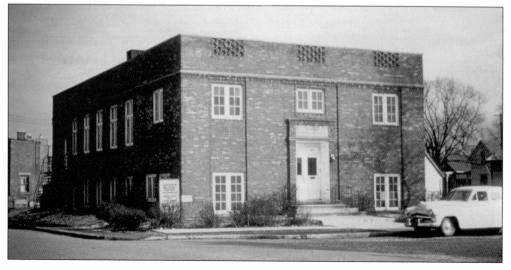

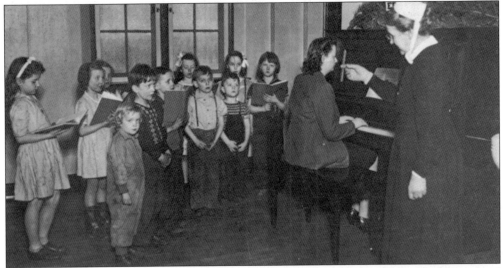

Sr. Nanca Schoen leads the children's choir at the offices of the Lutheran Welfare League around 1930. In addition to its choir program, the Gift Street location offered other services like manual training for boys, sewing for girls, and other daily activities. (Courtesy of the Lutheran Social Services of Central Ohio.)

Dorcas Shop was a small structure built next to the Lutheran Welfare League's headquarters on Gift Street. It was operated as a thrift store for residents and ran by volunteers. The shop also offered assistance programs to people in need. (Courtesy of the Lutheran Social Services of Central Ohio.)

Pictured above, between 1920 and 1930, is one of the mentally handicapped members of the Lutheran Welfare League being trained to sand and finish an old barstool. He is scraping off the paint; next, he will be instructed on how to use the electrical sander that sits behind him. Pictured on the right is another disabled member who is taking one last look at the cabinet he had just completed. One of the programs the organization offered was teaching disabled residents a skilled labor, giving them new opportunities to grow, participate in the community, and learn a trade that can earn them money. (Both, courtesy of the Lutheran Social Services of Central Ohio.)

The Lutheran Welfare League was not just about giving financial help or material goods to families in need. There was a strong focus on developing lifelong skills that would benefit the members, no matter what age, well after they finished the classes. Pictured left, an older man learns how to work with hand tools. In the photograph below is a group of neighborhood girls who were enrolled in the girls' club. One of the lessons learned in girls' club included cooking classes, taught in the kitchen of the Gift Street building. The girls pose excitedly with the finished product: a fresh batch of marshmallow goodies. (Both, courtesy of the Lutheran Social Services of Central Ohio.)

A group of children play a game of baseball behind the Lutheran Welfare League's building sometime around 1930. The downtown skyline can be seen in the background, which appears vastly barren compared to the skyline one would see from Gift Street today. (Courtesy of the Lutheran Social Services of Central Ohio.)

On April 11, 1917, a group of residents began to meet in a private home in the far west. The faith-goers organized Columbia Heights United Methodist Church as a Sunday school and the first Methodist Church. When the size grew large enough, they moved to a small house gifted to them by the community on Maple Drive. They moved to the budding Lincoln Village neighborhood in 1954. (Courtesy of Nola Freeman.)

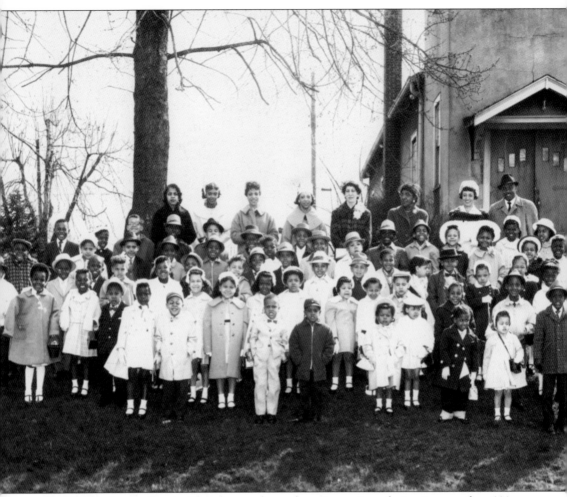

The Oakley Avenue Baptist Church was relocated numerous times during its more than 114-year-old history, but one of the earliest sites was at the corner of Oakley Avenue and Sheridan Street. Rev. Jacob Ashburn was known for regularly visiting the homes of his church members, going house-to-house to check in on their well-being. He dedicated his life to ensuring his community was healthy, both physically and spiritually. Oakley Avenue Baptist Church was later renamed the Oakley Baptist Church when the pastor's son Jacob Julian took the reins of the parish. The church would years later change its name again, this time to the Oakley Baptist Full Gospel Church, and move locations to 3415 El Paso Drive. (Courtesy of the J. Ashburn Jr. Youth Center.)

In 1941, the Columbus District of the Methodist Church and the Riverside Charge surveyed 633 Westgate-area residents and discovered a need for a local church after the West Broad Street church became vacant. Westgate Methodist Church's first service was held December 7, 1941, until a site for the new church was purchased at 345 South Brinker Avenue, across from Westgate Park. The basement level was completed by 1949. The members held services in the basement for a number of years, until they could raise $72,000 to expand the building. On December 22, 1955, the church held its first service in the new sanctuary, followed by two traditional Christmas services. On June 7, 1968, the church was renamed Parkview United Methodist Church after the Methodist Church and Evangelical United Brethren Church merged. The name change also helped also avoid confusion with another Westgate United Methodist Church already in the area. (Both, courtesy of Dan Gatwood.)

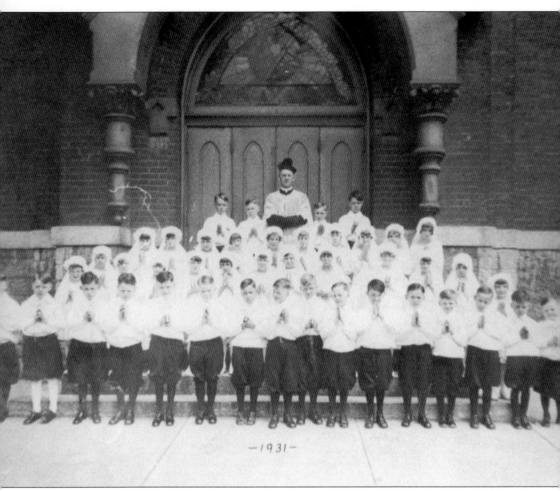

—1931—

Parish children are at their First Communion ceremony in 1931 at Holy Family Catholic Church, located at 584 West Broad Street. This was the first Catholic church to serve West Columbus residents; it was built as an Irish parish in 1877. In 1931, the parish priest was Fr. George Gressel, pictured with the children above. Holy Family has survived a number of disasters since it was first built. As one of the older churches, it faced a number of floods. It also fell victim to a fire in the mid-1950s and dealt with the impact of three freeways being built around its land. It withstood all these events, though, and continues to thrive. The church has created a number of programs to help the needy, including soup kitchens, various ministries, and the Jubilee Museum. (Courtesy of the Columbus Metropolitan Library.)

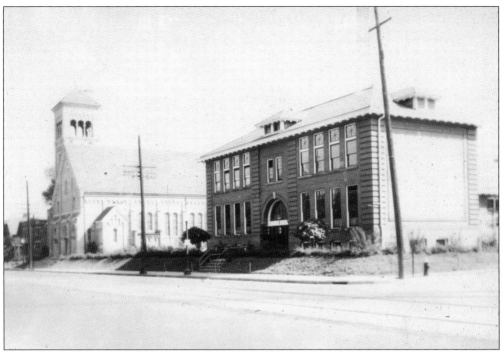

The St. Aloysius Roman Catholic Church stands at the heart of the Hilltop, located at 2165 West Broad Street. The church completed its construction in July 1927. It held a dedication ceremony on April 22, 1928, and was the third Catholic parish to serve residents in the neighboring communities. The church's school building can be seen in the foreground. (Courtesy of the Columbus Metropolitan Library.)

Pictured here is the Holy Family Catholic Church's rectory, which housed the parish priest. Built around 1900, it has since undergone a number of renovations, but it still stands next to the church to this today at 584 West Broad Street. (Courtesy of the Columbus Metropolitan Library.)

DISCOVER THOUSANDS OF LOCAL HISTORY BOOKS FEATURING MILLIONS OF VINTAGE IMAGES

Arcadia Publishing, the leading local history publisher in the United States, is committed to making history accessible and meaningful through publishing books that celebrate and preserve the heritage of America's people and places.

Find more books like this at
www.arcadiapublishing.com

Search for your hometown history, your old stomping grounds, and even your favorite sports team.